# A Due Voci

David Lloyd
112 Candee Ave.
Syracuse, NY 13224

SYR 132 09/17/97 #7 21:48

Cog Railway 1870s
20 USA

Rita Hammond
PO Box 284
Cazenovia, NY 13035

## Danse Russe

If when my wife is sleeping
and the baby and Kathleen
are sleeping
and the sun is a flame-white disc
in silken mists
above shining trees,—
if I in my north room
dance naked, grotesquely
before my mirror
waving my shirt round my head
and singing softly to myself:
"I am lonely, lonely.
I was born to be lonely,
I am best so!"
If I admire my arms, my face,
my shoulders, flanks, buttocks
against the yellow drawn shades,—

Who shall say I am not
the happy genius of my household?

—William Carlos Williams

• Two voices should read the poems out loud simultaneously •

## Danse Russe (*a due voci*)

If when I see his wife sleeping,
and his daughter and baby sleeping
in the bedroom,
and the sun shining in mist
above unfamiliar trees
in a strange yard,—
if I in the north room,
unbutton and unzip myself
and dance, naked, grotesquely
before the mirror,
waving his white shirt
round my head
and singing softly to myself his words
about loneliness.
If I admire my face and my body,
older than I remember,
against the discreetly drawn shades,—

Who shall say I am not
where I always wanted to be?

—David Lloyd

# A Due Voci

## THE PHOTOGRAPHY OF *Rita Hammond*

Edited by Julie Grossman, Ann M. Ryan, and Kim Waale

Syracuse University Press

03 04 05 06 07 08    6 5 4 3 2 1

The paper used in this publication meets the minimum requirements of American National Standard
for Information Sciences—Permanence of Paper for Printed Library Materials, ANSI Z39.48-1984. ∞™

LIBRARY OF CONGRESS CATALOGING-IN-PUBLICATION DATA

A Due voci : the photography of Rita Hammond / edited by Julie Grossman,
Ann M. Ryan, and Kim Waale.— 1st ed.
p.  cm.
ISBN 0-8156-0751-2 (cl. : alk. paper)
1. Hammond, Rita, 1924–  2. Women photographers—United
States—Biography. I. Hammond, Rita, 1924–   II. Grossman, Julie. III.
Ryan, Ann M. IV. Waale, Kim.
TR140.H26 D84 2002
770′.92—dc21                                     2002151154

FRONTISPIECE: Lloyd after Williams
"Danse Russe" by William Carlos Williams, from *Collected Poems: 1909–1939*, Vol. I, copyright © 1938 by New
Directions Publishing Corp. Reprinted by permission of New Directions Publishing Corp.

Design by Christopher Kuntze
Printed and bound by Friesens
Manufactured in Canada

*To Rit*

1924–1999

# Contents

## Donors

The Bernstein Fund

Mrs. Elliot Bernstein

Dr. and Mrs. Howard Bernstein

Jim and Jeanne King
   *Hammond after Cézanne*

Sharon Ahlers and Anthony DiRenzo
   *Hammond after Nijinsky*

Lex and Donna Bernstein
   *Hammond after Mapplethorpe, Self-Portrait [with cigarette]*

Mary Selden Evans
   *Hammond after Oldoini*

Barnet Kellman and Nancy Mette
   *Hammond after Brooks*

Lynn W. Moser
   *Hammond after Durand*
   *Hammond after Nadar and Tournachon*
   *Hammond after Chardin*

In loving memory, friends of Ben Semmel
   *Hammond after Arnold*

Donald and Christa Baxter

Steven Bernstein

Virginia and John Felleman

Jennifer Glancy and David Andrews

Ruth Hancock

Ellen Jaffe

Mary MacKay and Edward Wheatley

Virginia Moser McGuinn

Julia C. Moser

Mrs. Stephen Moser

Sandy Palmer

Joel Potash and Sandra Hurd

Elizabeth A. Salvagno and Barron Boyd

Peg and Chuck Sherwin

Robert and Sally Sugarman

Linn Underhill and Ann Carter

# Foreword

JEFFREY HOONE

In 1967, only a short time after taking up photography, Rita Hammond spent the year photographing her friend Lynn Moser. In this series of portraits entitled *Images of a Girl*, Hammond established several themes that inform the work she would produce over the next twenty-eight years. In *Images of a Girl*, Hammond creates a representation of a young woman who claims her youth, beauty, and independence for herself. Twenty years later Hammond photographed Moser again for the series *Images of a Woman*. With the passing of time, we are drawn into the personal histories of both women; we witness their sustained friendship and the endurance of Hammond's initial observations. In *Images of a Girl* and *Images of a Woman*, Hammond looks inward at a close and personal friendship to find confidence and comfort. With these lessons learned, Hammond continued to look outward to make connections between her personal observations and the larger world of images and ideas.

Hammond's most sustained method for making these connections was her use of self-portraits. In one series, Hammond collages images of herself into reproductions of renowned paintings. By placing carefully considered photographs of herself into these revered works of art, she makes them more accessible for herself and the viewer. It is as if she has crashed an exclusive annual party and then discovers that she has always been on the guest list. When we see Hammond in these collages peering over the shoulder of one of Cézanne's *Card Players*, or sipping water through a straw from a fountain in Bellini's *Feast of the Gods*, we recognize immediately that Hammond includes herself in the larger frame of art history—a history that, for the most part, has excluded women. Hammond's approach is playful and humorous, as if to say, "there is room in these great paintings for me to enter, to absorb their genius and make them part of my experience."

In *A Due Voci*, Hammond emulates the self-portraits of other artists and continues to press on with the conviction that art, culture, and history are processes to participate in and not just sources of icons to venerate. In one of these works, Hammond pays homage to the tough and independent actress Louise Brooks, while in another she casts herself as Robert Mapplethorpe, bending our perceptions of gender and sexuality. If Hammond's love of play is demonstrated in her response to the notion of a fixed gender identity, it is reinforced in this series in her various photographs of herself as a clown. Hammond has been influenced by the commedia dell'arte, a tradition of free-

spirited satire that was initiated in sixteenth-century Italy by street performers poking fun at politicians and aristocrats. The image of a clown appears in Hammond's work over and over again. Two favorites, Nijinsky and Deburau, are included in this group in a somber mix of humor, pathos, and carefully measured self-deprecation.

Hammond brings her work full circle from *Images of a Girl* in the triptych entitled *They Would Be My Age Now*, which she made in 1994 just after her seventieth birthday. In this piece Hammond's self-portrait is flanked by a passport photograph of Anne Frank and a publicity portrait of Marilyn Monroe. Between Monroe's glamour and unabashed sexuality and Frank's unflinching innocent perseverance, Hammond is poised as the survivor who pays homage to her fateful contemporaries, embracing the diversity of their independence and the weight of their sacrifices. As a result of unresolved copyright issues, this triptych could not be reproduced here. Breaking rules was always one of Rita's best strategies and most endearing qualities, whether her transgressions involved appropriating images or doing something that was supposed to be impossible.

Throughout her work, Hammond encourages us to claim the power of art and history and culture, and to make that power our own. These convictions seem to be echoed in a traditional African proverb that declares, "Until the lions have historians, history will always glorify the hunter." In her work, Rita Hammond encourages us to claim the records of history, art, and culture for ourselves so that they may never become the exclusive story of the hunter.

Just before Rita died, she donated her archive of photographs to Light Work, an artist-run nonprofit photography center in Syracuse, New York. Some of the images in the archive will be donated to museums in Central New York, and it is our aim to have her work placed in museum collections across the country. The work that remains in Light Work's collection will be available for viewing on its website and available for research and exhibitions. Rita's work deserves a much larger audience than it enjoyed during her life. Rita's many friends and admirers hope that the publication of *A Due Voci: The Photography of Rita Hammond*, as well as the availability of her work for exhibition loans and research, both from Light Work and other collections, will widen her reputation and expose new audiences to the work of this gifted artist.

# Acknowledgments

We have dedicated this book "To Rit," as she was affectionately known to us all. Editing this volume has deepened our appreciation for Rita's work and drawn us closer to our good friend. We especially want to thank Howard Bernstein, whose devotion to Rita inspired this book, and Lynn Moser, whose love and friendship enriched Rita's life and her art.

Julie would like to thank Phillip Novak, whose skills as a writer have sharpened her own, and whose affection and loving support withstood unending conversations about the nature of copyright. She would also like to thank Sophie Jo Novak, whose good cheer makes every day brighter. Julie wishes, as well, to express her gratitude to the women in her family—Paula Grossman, Tiny Rosoff, and Amy Breiger—for being smart, proud, and accomplished, and for encouraging her to be the same. Finally, she would like to dedicate her own efforts in this book to the memory of her father, Joseph Grossman, whose brilliance continues to provoke her. Ann would like to thank Tom Kennedy for his smart and careful reading, his affectionate support, and his wonderful good sense. She would also like to thank John M. Ryan for teaching her to tell jokes and talk to strangers. Ann would like to dedicate her work to Jeanne B. Ryan, a loving mother, a true friend, and a class act. Kim is indebted to David Lloyd for his deep interest in this project and for sharing his expertise as an editor. She is also grateful to her daughter, Nia, for patiently napping through so many editorial meetings. Lastly, Kim is grateful to Rita for teaching her how to think like an artist.

We would also like to thank Pat Bernstein, Eliot Bernstein, Ray Beale, Launa Beuhler, Deborah Bright, Michael Davis, M. J. Devaney, Lauren DiMarco, Annabeth Hayes, David Hayes, Elizabeth Hayes, Jeffrey Hoone, Christopher Kuntze, Elizabeth Myers, Sylvia Needel, Tyler Ochoa, Charles Palermo, Christian A. Peterson, Dorothy Reister, Carol Satchwell, John Short, Karen Steen, Allyn Stewart, Mary Ann Stavenhagen, Nancy Wright, the staff of Syracuse University Press, the Le Moyne College Research and Development Committee, Cazenovia College, Light Work, and The Bernstein Fund. We would like particularly to thank Mary Selden Evans, our editor at Syracuse University Press, whose limitless enthusiasm and support have moved this project along, and Hugh Tifft, whose skills as a photographer have brought the best out of Rita's work.

Finally, *A Due Voci* testifies to the staying power of good friends—and girlfriends in particular.

*Lovely Rita*

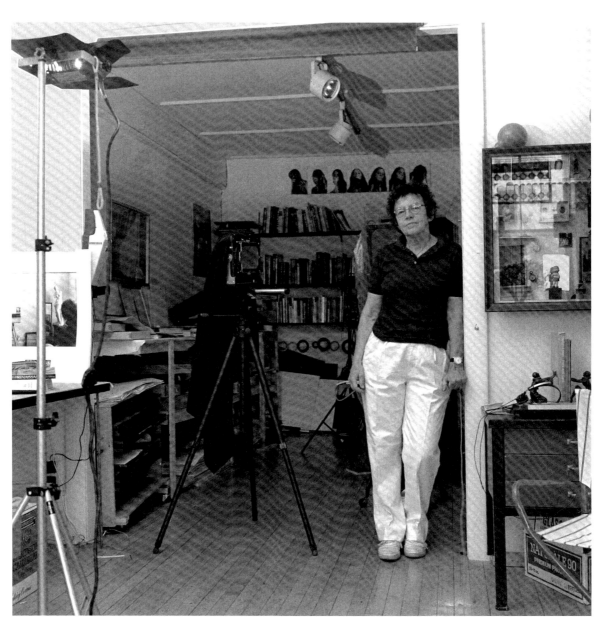

Hammond in her studio

# Introduction

In 1929 Virginia Woolf attempted to explain the apparent failure of women to contribute significantly to Western culture and civilization. As she surveys English literature in particular, she encounters a history of female absence and silence, punctuated only by the occasional voice of some woman crying out in the wilderness—or, in the case of Charlotte Brontë, laughing in the attic. Although Woolf speculates upon the fate of a mythic Shakespeare's sister and the forces that made her poetry an impossibility, ultimately she is less interested in communing with ghosts than in setting the stage for a real and living artist. To that end, Woolf concludes that before the female artist can have a cultural history she must at least have a moderate income and a room of her own. If women, according to Woolf, have "five hundred a year each of us and rooms of our own; if we have the habit of freedom and the courage to write exactly what we think; if we escape a little from the common sitting-room and see human beings not always in their relation to each other but in relation to reality; and the sky, too, and the trees or whatever it may be in themselves . . . then the opportunity will come and the dead poet who was Shakespeare's sister will put on the body which she has so often laid down" (1957, 117–18).

In 1966 Rita Hammond followed Woolf's prescription and rented a room on Albany Street in Cazenovia, New York. Hammond intended this space for a studio primarily, yet it also became a central vehicle for her art and an almost theatrical space in which Hammond performed with herself as the primary audience. Although Hammond had a home—complete with a husband and two children—she had no space in which to explore her identity "in relation to reality." The room on Albany Street became a focal point for this endeavor: it was at once a studio, a personal retreat, a boudoir, an artist's salon, and a lecture hall. She kept film in the freezer and wine on the table; she used a bed as a sofa and the kitchen as a dark room. During this period, Hammond also began a concentrated study of art history, even as she tried to find her place in it. Finally, she started to look carefully and critically at the world around her, while she invited—often demanded—that the world look back at her. For the first time, Hammond began to photograph herself extensively and seriously—a process that would continue for the next thirty years—and frequently she did so in her newly acquired studio. Of course, this space was not the ideal, solitary retreat that Woolf had imagined for her artist. If Woolf feared that social obligations threatened to make women ornamental and marginal, Hammond, by contrast, was drawn to beautiful

and interesting people, and she loved to be at the center of their conversation. If Hammond had not quite escaped social relations in this little room, as Woolf may have wished, she at least found a place where those relations could exist on her own terms, and where she could represent herself without apology. This studio was the first of three, the last of which would function as both home and studio; in each case, Hammond rented space above shops or restaurants, always providing for herself an interesting view of the world and a secure distance from which to observe it. For almost forty years, Hammond hovered about, around, and over Albany Street, at once recording the world around her and projecting herself onto it.

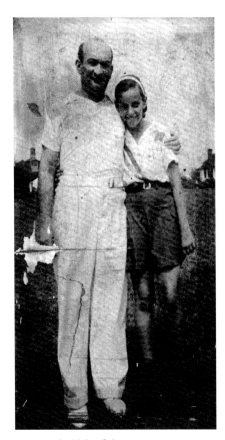

Hammond with her father

In many ways, Hammond had been searching for a room of her own since her childhood. Hammond was born Carol Rita Semmel in New York City in 1924, and while she would spend most of her life in upstate cities and villages, she would always be a product of the city. Hammond grew up in a small apartment, where the dining room doubled as her bedroom. Still, despite the hardships of the Depression, Hammond recalled her childhood as being filled with small treasures: candy for a nickel, playtime in the park, and even an occasional matinee on Broadway. Many of her fondest memories centered around her trips to Lawrence, New York, on the southern shore of Long Island, where she would visit with her cousins Howard and Eliot Bernstein. Howard Bernstein would later recall that while the young Rita could play "rough and tumble" with the boys, it was clear even at a young age that "Rita saw the world with an artist's eye; she could turn a simple family slide show into a work of art, complete with music and everything" (Bernstein 2001). Hammond lived in New York until she was thirteen years old, at which point her father's health began to fail. The family moved to Saratoga Springs, and Rose Semmel began to manage a small boarding house, "The Elbern," which was originally owned and operated by Hammond's maternal grandparents.

Hammond's relationship with both her parents informed many of the choices she would make later in life and set the stage for her evolution as an artist. In her father, Hammond found a kindred spirit, full of charm and born for fun. Edward Semmel was an original bon vivant who loved to golf, to read *The New Yorker*, and to laugh with the child he called "Rita." Hammond embraced many of his traits and interests as a kind of paternal legacy. Most important, she adopted her father's belief that life was meant to be enjoyed, and that the ability to do so was a talent worth cultivating. Edward died suddenly in 1937 of a heart attack, and Hammond recalled the loss as one of the most devastating of her life. After his death, Hammond's mother ran the hotel for several years, providing for Rita and for her extended family as well. Rose Semmel lived into her eighties, and for all those years, Rita would recall that her mother could only afford to be concerned with "moment to moment survival" (Hammond 1999). A

warm and caring woman, she was equally determined and rigorous. It seemed to Hammond that her mother drew some comfort from the predictability of a house in order. Forced in part by circumstance and drawn by her own disposition, Rose Semmel spent her life cooking, cleaning, and making order for those around her—friends, family, and strangers alike. Rita Hammond greatly admired her mother's resolve and strength of character—traits she possessed herself—yet, she saw her mother's life as a kind of fate shared by many women of the time whose options were few and whose world was necessarily circumscribed. Hammond longed for something more. In time, she would both follow in her mother's footsteps and carve out a path of her own.

For several years after her father's death, Rita Hammond lived in the Elbern with her mother. A large Victorian structure, the Elbern housed vacationers and boarders of all sorts, drawn to Saratoga for the waters, the racetrack, the artistic community, or the natural beauty of the Adirondack foothills. Hammond was surrounded during her adolescence by the sorts of people she would attract as an adult: artists and writers, adventurers and gamblers, entrepreneurs and runaways. While living in Saratoga, Hammond got her first glimpse of the high life, and she never forgot the view. It was in Saratoga that Hammond fell in love with the racetrack, that she learned to appreciate beautiful architecture, and that she began to value a certain level of excitement and fascination in her friends and associates. Hammond recalled with particular fondness the yearly arrival of a spectacular red-haired actress from New York who seemed to be the Elbern's very own "Gilda." Yet, despite the inherent drama and glamor of life in a boarding house, which Hammond enjoyed intensely, she also longed for some normalcy and solitude. Hammond's recollections of her life at the Elbern illustrate this tension: "Since the bedrooms were occupied by paying guests—I slept in the front room on a couch by the bay window. The only time I had a real bedroom—a private room for myself—was one winter. I loved this room so much. . . It was a corner room upstairs, and had a fine view and plenty of sun. I remember waking on Sunday morning and feeling cozy and not having to get up. I would imagine I had a big family with many brothers and sisters. I was an only child" (Waale 1997). Her love of privacy and her dreams of companionship would be in contention throughout Hammond's life. She seemed always to be in the process of negotiating the space around her: yearning for intimacy and keeping her distance; working her way into the center of the picture, while also managing to stay out of the frame.

After graduating from Cazenovia College, then a two-year women's school, Hammond would experiment with visions of domestic happiness. In 1946 she married Charles Hammond, and the next twenty years were devoted to raising her two children, Edward and Deborah. For a while, Hammond and her family lived in Syracuse,

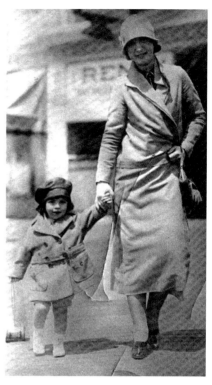

Hammond with her mother

New York, until Charles got a job teaching English at Cazenovia College, at which point Hammond returned to her alma mater and to the town that would occupy such an important role in her artistic awakening. Cazenovia of the 1960s and 1970s was the ideal spot for Hammond to sort out her competing desires: for domesticity and stability on the one hand, and independence and adventure on the other. Located on the shores of a small lake, Cazenovia is a bucolic village, ideal for raising a family. Yet as a college town, Cazenovia also provided Hammond with a continual source of inspiration and provocation. Like her childhood home of Saratoga, Cazenovia attracted a wide variety of people, many of whom were in various states of personal, social, and artistic experimentation. It wasn't long before Hammond became restless. In 1961, Hammond began taking classes at Syracuse University as an English major. That same year, Hammond attended an exhibit of Harry Callahan's work at the Museum of Modern Art. Although she had expressed an earlier interest in photography, she credited this event with beginning her career as a photographer.

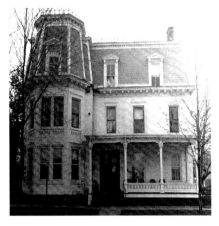

Hammond at Elbern

That Callahan would become a source of inspiration for Hammond is hardly surprising. His photographs display a profound appreciation for the beauty of the commonplace, with a nonetheless romantic conception of the role of the artist. Unlike his mentor, Ansel Adams, who relied upon vast landscapes to communicate dramatic revelations, Callahan shared with his audience highly specific insights into the transcendence of the everyday: Callahan finds a taxicab at an intersection and the photograph captures a kind of wonder in the discovery. Hammond clearly sympathized with the immediacy and clarity of Callahan's aesthetic, as many of her earliest photographs and portraits demonstrate. She discerned an intensity within the simple details of her surroundings: in the streets of Cazenovia, in the faces of her friends, the patterns in stones, or in the landscape of her own living room.

Yet, one aspect of Callahan's work that resonated most with Hammond did not surface until several years later, when she had learned the basics of her discipline and had become committed to life as an artist. Callahan spent years photographing his wife Eleanor; she was his muse and his subject matter. Hammond would likewise find herself drawn into a lifelong collaboration with a fellow artist who would at once inspire and provoke her work, Lynn Moser. In 1967, Hammond's first major show, *Images of a Girl*, would capture the twenty-year-old Moser in many various moments and attitudes. Rather than simply documenting Moser, these photographs—eighty-two in all—suggest a life beyond the scope of Hammond's lens. At this moment in her development as an artist, Hammond was fascinated with the possibility of eliminating artifice, and she aspired to represent an immediate truth in her photography. Eventually she would discard such an ambition as being in itself artificial, and she would embrace the notion that all acts of representation are theatrical, just as individual identity—gender,

sexuality, age—is perhaps a self-conscious conceit. Even in this early work, despite Hammond's claim that she is attempting to represent Moser without filtering or framing her impressions, there is a great deal about these images that is intentionally beautiful and occasionally posed. Although Hammond imagined herself early in her career as a kind of photojournalist, recording both the transient and transcendent in the world around her, she was equally drawn to the notion of the artist as a gifted individual. Like any number of classical artists, Hammond enjoys and cultivates the process of being inspired, and her photographs reflect that process. Born out of Hammond's burgeoning awareness of her love of women, *Images of a Girl* is a series of portraits of a young woman who is at certain times acting the part of, at other times simply embodying the role of, the muse.

Of course, Hammond was too aware of the inherently patriarchal structure of the artist-muse relationship to have explored either of these roles without some degree of skepticism. Layered within several of these portraits are other portraits of other women, occasionally even other images of Lynn Moser. All of which raises the question of who or what happens to be the source of inspiration for these photographs. It may be that, despite her obvious fascination with the appearance and the reality of her subject, in *Images of a Girl* Hammond is effectively recording her own sexual and artistic awakening. What is most interesting about *Images of a Girl*, particularly considering Hammond's later artistic concerns, is that even in these early portraits Hammond creates a dialogue between the artist and the subject. Hammond's photography breaks down the static relationship between the observer and the observed and replaces it with the dramatic fluidity of conversation. Hammond returns to this series twenty years later with *Images of a Woman* (unpublished), where she photographs Moser again and anew, establishing a dialogue not simply between Moser as girl and woman, but also between Hammond's own early artistic vision and her matured sense of herself as an artist. There is a kind of "call and response" at work within these two series of images that moves beyond the simple comparison of past and present selves. In one early portrait Hammond stands over Moser, hands on her shoulders, looking as if she is about to speak, while the young Moser appears self-possessed and silent, enjoying her role as muse. In the later version of this portrait, Hammond has relinquished the dominant position, while retaining certain features of the original: like the young Hammond, her mouth is still open and she still seems ready to leap out of the frame. In this way, the later portrait revisits the patriarchal Hammond of the earlier one. Moser, though still nominally the muse, appears less an object and more a subject. No longer passive under the camera's gaze, she has become an agent in her own representation. These reversals and continuities suggest a relationship in process, an evolving narrative occurring both in and outside the frame.

Much would change during the course of their thirty-year relationship: Moser moved to Seattle; Hammond began to teach art history and photography at Cazenovia College; both worked independently on their own projects and their own lives. Hammond would work in collaboration with other artists in addition to Moser, most particularly photographer Ray Beale and sculptor Kim Waale, both of whom contributed significantly to perfecting Hammond's vision in "A Due Voci." Yet Hammond and Moser always imagined their friendship as an integral part of their art. Lynn Moser recalled that her relationship with Hammond began with a trip to Europe in the summer of 1968 and continued for many summers to follow. During her breaks from teaching at Cazenovia College, Hammond would join Moser on a series of cross-country adventures. In 1970 they drove through the southwest, and Hammond was able to cajole, charm, and complain her way into the home of Georgia O'Keefe for a visit with the elderly artist. In 1971 and 1973 they traveled throughout Washington State and over the coastline of Oregon and California. In 1977 they drove across Canada and through the Maritime Provinces, and in 1980 they explored the southern states. They culminated their travels in 1989 with a tour of southeast Alaska. Moser recalls that "the trips began as personal photographic explorations, and became the basis for future collaborations. Often our way of referencing them would be through allusion to the car driven that year: gray Volvo, tan Mercedes, red camper, red Mercedes, tan Range Rover. The cars were all named and were, in a sense, a third companion on the jour-

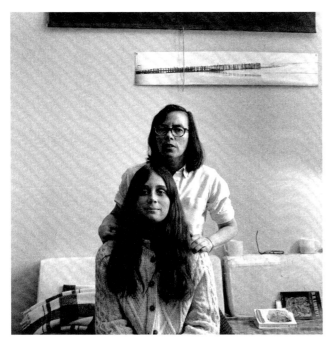

From *Images of a Girl*, Hammond and Moser

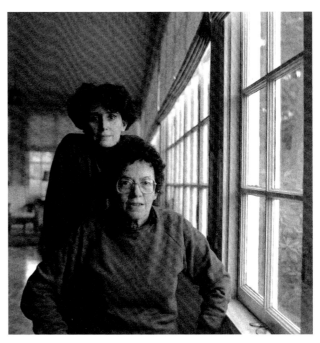

From *Images of a Woman*, Moser and Hammond

neys. They carried our conversations, readings out loud, and found roadside treasures. In the case of the camper they became home for weeks at a time" (Moser 2001).

*Hammond and Moser, Rock Triptych*

The final significant collaboration of Hammond and Moser is a series of triptychs that essentially reinvent their previous journeys together; their photographs began by documenting their travels, and now the photographs would travel between two coasts as a kind of testimony to their relationship.

Between 1993 and 1997 the two artists exchanged a series of photographs, each in response to an earlier image, and all of them centered around a stone that Moser described as having "white spectral markings, in circular patterns." According to Moser, "The center photograph of the triptych was always the rock. Initially, one of us would respond to the rock with another photograph (placed left or right of the center). This partially complete image would then be mailed out, and the final response would be to the two photos already laid down. Whoever placed the last photograph would begin the new series" (Moser 2001). One of the goals of this project was to expose what Freud called "the uncanny"; that is, to demonstrate visually the hidden and even the spontaneous connections between two dissimilar items. Yet, if this series seems to celebrate the suddenness of insight and the shock of recognition, it also highlights the value of sustained dialogue and intimacy as a framework for art, just as it privileges the creative process over the creative product. In *Images of a Girl* and *Images of a Woman*, Hammond's photographs reference a life beyond the frame. Similarly, in the "rock book," as it was familiarly called, Hammond and Moser create a subtext for the work that is their own long-standing relationship. For the audience, this series of photographs reads like a conversation between two old friends: at once graceful and witty, collaborative and competitive, frank and knowing. These photographs banter and quip in a way that will become distinctive in Hammond's final body of work, "A

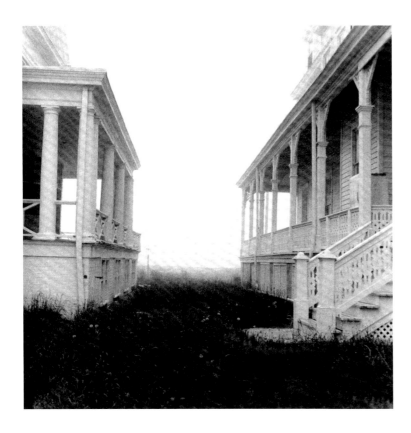

From the Cape May series

Due Voci," and they aspire to the same goal: to make connections and find correspondences. Hammond once wrote to Moser of the lovely, synchronous quality of their shared lives and artistic collaborations, "I'm twice your age, but we will have the same memories" (Moser 2001). To some extent, Hammond worked to establish a similar sense of communion with her audience. Hammond took great pleasure in leading us through a series of associations, juxtapositions, and analogies—stringing us along, teasing us into appreciation—all in the hope that we would be able to follow, to make these same connections, and most importantly, to join in the conversation.

Beyond her collaborations with Moser, Hammond produced an impressive body of work, much of which deals with architectural space. Having grown up in the Elbern, Hammond had a particularly nostalgic response to old and rambling houses. She spent a great deal of time photographing Victorian homes on the coast of Cape May, New Jersey, and in the area surrounding Cazenovia. Many of these images were subsequently exhibited in her 1976 show at Light Work in Syracuse. Photographing these structures allowed Hammond to contemplate the nature of intimacy through an examination of domestic space. Several of the photographs focus on the nearness of these homes to each other, so that their large and ornate porches almost touch, making them seem to be confidantes. While there is an implicit warmth about these pho-

tographs, they also recall the inevitable decay of homes and families. The beachfront houses appear deserted, accompanied only by sand and wind. And if Hammond seems interested in the relationships between the structures, she also clearly illustrates the spaces that divide them, often centering her photographs around porch railings and narrow yards. Occasionally, Hammond's portrait of a home becomes an illustration of an empty space.

In her next major project, Hammond continued to work with architectural subjects, though on a much smaller scale. In a series of three-dimensional boxes, inspired in part by the work of Joseph Cornell, Hammond constructs boxes filled with unreal images and objects that are magical in effect and playful in tone. Yet she also draws on her own experience to inform this work. Among all the varied jobs Hammond held before working at Cazenovia College, she spent some time as a window dresser in New York. And like any striking shop window, these boxes seem to be outward-looking showcases, demanding our attention and inviting us into some interior world. In a piece entitled *Friday's Child*, Hammond creates a dream space in which she represents the essential elements of her identity. Like a child's treasure chest, it is filled with beautiful stones, shells, and marbles, as well as a colorful drawing of drummer boys. Yet layered within these innocent references are the experiences of the adult Rita Hammond: a Menorah, a racehorse, and a frayed and yellowing portrait of a dancing minstrel—perhaps Hammond's most pointed self-reference. At the bottom of the piece is a small calendar of the month of May 1924, and Hammond has circled her own birthday: May 30th. *Friday's Child* is a child's birthday party that has been filtered through

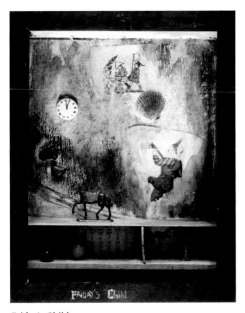

Friday's Child

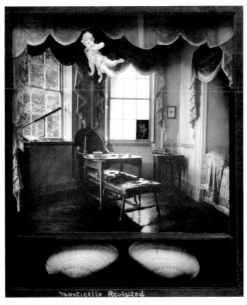

Monticello Revisited

the imagination of an old woman. In another of these boxes, entitled *Monticello Revisited*, Hammond plays with cultural memories rather than with her own. In this piece, we get an indication of things to come; Hammond enters the sanctum sanctorum of American history—the bedroom of Thomas Jefferson—and plays with the cultural significance of the space. She surrounds it with ornate, theatrical draperies, she encloses it within a diminutive box, and she punctuates the entire work with a hovering, pink-lipped cherub. Finally, in one of Jefferson's windows, she places a portrait of Richard Nixon, who seems to be looking down at Jefferson's writing desk. Hammond has ironically positioned the reality of American monarchy against the myth of American democracy. Nixon, the would-be tyrant, and Jefferson, the slave-owning democrat, compete for primacy in this space; yet, they also are both palpably and pointedly absent from the work, appearing as references only. In their place, Hammond inserts her own sense of humor, turning the stage of history into her playground.

In this volume we have included three bodies of work: "A Due Voci," "Hammond Canonized," and "Celebrity." Collectively, they narrate Hammond's artistic awakening, her transformation from being a student of history to claiming her own space in history, from observing celebrities to becoming one. "Celebrity," one of her earliest series of photographs, not only reveals her fascination with glamour, in this volume it also foreshadows her movement into the frame of the photograph. Then, in "Hammond Canonized," she transgresses the boundaries of conventional notions of art and history. She seems at home in Vermeer's studio, and she's equally sure that Campin's St. Joseph could use her advice. Hammond's greatest artistic achievement, however, comes in "A Due Voci," her final work and the first in this volume. Here, Hammond's concern with the nature of artistic achievement and with the possibility of a woman becoming a "great master" is utterly resolved. In "A Due Voci," she is as pretty as Marilyn and as tragic as Bayard; she's got Warhol's sense of humor and Mapplethorpe's sense of style. If Hammond is wondering about greatness, talent, and success, she no longer appears to be wondering about her own.

Hammond began her professional studies with Nathan Lyons at Rochester's Visual Studies Workshop, as well as at the George Eastman House. She secured an academic position and was for twenty-three years an instructor of art history and photography at Cazenovia College. Hammond's work has been the focus of solo exhibitions at the Everson Museum, the Menschel Gallery, and the Dana Arts Center of Colgate University; twice she was a recipient of the New York Foundation for the Arts photography fellowship. Toward the end of her life, Rita Hammond's photography was beginning to receive national interest and recognition. Her work was included in *The Passionate Camera: Photography and Bodies of Desire*, edited by Deborah Bright, an anthology of the works of gay and lesbian photographers whose images explore the nature of sexuality

and confront the history of its visual representation. At the age of seventy-three, Rita Hammond was in the process of being "discovered."

Certainly, Hammond's relative anonymity was, in part, a circumstance of her own choosing. Behind Hammond's conflicting response to the nature of success, there is something vital and original; there is a kind of wonderful carelessness, a radical lack of concern for the opinion of others or the judgment of the world. Hammond didn't cling to her reputation or commodify her work, preferring instead the process of creating art to the relative tedium of buying, selling, or showing it. Of course, none of this is to suggest that Hammond was above a little bartering. In the fall of 1998, she was diagnosed with cancer, about the same time she was finishing "A Due Voci." With characteristic nonchalance, Hammond decided to have a yard sale, the goal of which was to shake off all her excess and prepare herself for the various transitions to come. Among hundreds of images she put up for sale—photographs of church doors in Cazenovia and stairwells in Italy and old women on the streets of New York—she had a print of her Robert Kennedy portrait marked "Yours for six dollars." The gesture was typical of Hammond, at once asking her audience to value her work, while daring us not to take her too seriously. Despite her thorough enjoyment of life's pleasures, Hammond had a stoic's response to her own art; when it no longer served her purposes, when it no longer generated more ideas or more conversation, she moved on.

It would be convenient and sentimental to suggest that Rita Hammond chose to simplify her life after she was diagnosed with cancer, but the truth is that she never liked being tied down, whether it be by material goods, other people, or conventional expectations. In his essay "Walking," Henry David Thoreau distinguishes between the mere walker and the person with a genius for sauntering, and in many ways, Hammond had that genius. Thoreau claims that the word "saunter" comes from the French, "'Sainte-Terrer,' a Saunterer, a Holy-Lander." He continues, "We should go forth on the shortest walk, perchance in the spirit of undying adventure, never to return . . . if you have paid your debts, and made your will, and settled all your affairs, and are a free man—then you are ready for a walk" (592–93). It was in this spirit that Hammond approached both her life and her art. When she was forty years old, Hammond willed herself into the world of art, and for the next thirty years she continued to evolve as an artist—challenging her talents, shifting her perspectives, and acquiring new skills. Hammond seemed always to be at the beginning of some new adventure, even if she were simply walking down Albany Street. Yet, if she was a kind of pilgrim, she was without a holy grail; Hammond was not interested in art as an idol or a static object, but as a medium of self-exploration and as a form of dialogue. When she had nearly completed "A Due Voci," she sent out copies of the work to dozens of her friends and colleagues and asked them to reflect upon what they saw. Several of these

reflections are contained in this volume. Out of this collection of opinions and perspectives, Hammond did not hope to achieve harmony or completion; instead, she wanted to establish the rhythm of a good conversation—witty, maybe even contentious, and ongoing. Hammond ultimately imagined her own experience of art as a social event, a celebration where she was both hostess and guest of honor.

In the late spring of 1997 Rita Hammond had a small dinner party in her apartment/studio. She had gathered a group of friends together who were as varied as her cuisine, and she feted us as only she could. Toward the end of the evening, she dimmed the lights, and we prepared to view what we expected to be her latest work. Instead, what followed was a slide show consisting of a series of personal snapshots—Rita as a little girl in Saratoga, Rita in middle age, cruising on a motorcycle, Rita teaching a group of fascinated—and somewhat astonished—undergraduates, and finally, beautiful images of Rita's wonderful old age. We sat in the dark watching Rita's life unfold, realizing that perhaps this audacious act of self-representation—complete with soundtrack—was, in fact, the content of and context for Rita's art. While the Beatles' "Lovely Rita" played in the background, the photographs on the screen suggested the extraordinary accomplishment of Rita Hammond's life and art: she was a woman who had learned—to paraphrase Walt Whitman—to celebrate herself, "and what I assume, you shall assume/ For every atom belonging to me as like belongs to you" (1982, 27). In "A Due Voci," in particular, Hammond ignores the boundaries of identity, history, and gender, and she becomes whoever she wants to be, without ever ceasing to be herself. And more important, she suggests through her various incarnations that the same disconcerting and thrilling celebration is available to us as well.

We last visited Rita Hammond in Seattle shortly before her death on May 1, 1999. Despite her fragile health, she was still unabashedly and completely "Rita": lecturing on art history, speculating on images "to be taken," and deeply invested in the publication of "A Due Voci." We sat with her while she recorded her impressions of each pair of images: her sympathy for and with Hippolyte Bayard; the history of Countess de Castiglione and her fascination with this photo; Picasso's Harlequin, and the problems she had—technically, not philosophically—inhabiting that space. She also shared with us plans that she and Lynn had been working on to develop an artist's retreat, particularly for Rita, in Port Townsend, Washington. It was not—in all this talk of books to be published or homes to be built—that she was avoiding the inevitability of her own death; rather, she was still in the process of negotiating life, of finding her place in it. As she sat on the couch in her apartment, surrounded by friends and food and beautiful photographs, she reviewed an architect's drawing of a small house; it had a walkway leading outside to an even smaller structure that she had labeled

"Rita's room."

# After "A Due Voci"

It's cocktail hour. I'm drinking a glass of cheap red wine, as I did so many times with Rita in her studio in Cazenovia. We might have spent the day working together on a project, or maybe I stopped by after teaching my last class of the day at the college, a block from her studio. At these times, Rita often showed me images she was planning to use in "A Due Voci," a series in which Rita performed as herself in famous works of art—always taking the leading roles. Although she may have assumed the semblance of another artist's work, ultimately the *re-semblance* is not enough to fool us into believing Rita really wanted to become or to be *mis-taken* for that other work of art. It was obviously important for Rita to remain Rita in these images.

Occasionally, I found images I thought fit Rita's sense of "A Due Voci" perfectly. When I showed them to her, however, she invariably rejected them, sometimes with bemused appreciation, other times with a blunt "no." So, what are the criteria she used to select images to reproduce in "A Due Voci"? What was Rita trying to achieve when she cast herself as the main character (usually the only character) and set her version in an undisguised Hammond studio?

Fortunately, Rita asked me to help her with several of these photos, including attempts at some—a Rembrandt, for instance—that were never completed. The two most memorable photo shoots involved the Beckmann self-portrait and Picasso's image of a harlequin. The original works are both paintings. Working with Rita on the Beckmann revealed the tightrope she walked between reverence and subversion, as she developed her photographic relationship with the image. It paved the way for our more complex collaboration on Picasso's *Seated Harlequin*.

In Beckmann's self-portrait, the artist shows himself as a sailor. I helped costume Rita in something that resembled what Beckmann wears in his painting. I dug through her wardrobe and chose garments that were right in tone and detail to match the painting. While using the costume I selected, Rita dismissed my careful efforts at faithfully reproducing the image, telling me that I was missing the point. I also adjusted the "set" and lighting. I lit the scene carefully, so the highlights and shadows mimicked those in Beckmann's painting. I micromanaged the wrinkles in her shirt and twisted her thumb so she looked like Beckmann. She chastised me for being so picky and barked that it was "close enough"; I should hurry up. Rita was notoriously short of patience for things she deemed unnecessary, and I realized that I understood little of this project.

Then, in a turn-around, Rita told me to slow down, to wait a minute—what was the rush? She asked to see the picture of Beckmann's painting again, took off her glasses, and held the book close to her face. She studied the portrait (which she already knew so well) for a long time. She grunted and ahhhed. Then she tossed the book to the floor, dropped her glasses, and looked at the camera—assuming something like the feeling of the picture, not its appearance—and told me to take the shot. She ruined some of my picky arranging (my attempts at faithful replication) and instead communed with the spirit of the painting through the vehicle of the camera. Rita was, in that moment, fully engaging (physically, intellectually, and, I would say, spiritually as well) in a highly personal conversation with a long-dead artist through his artifact about his—or her—place in history.

I now understand that she chose pictures because she wanted to *know* them. For Rita this meant entering the pictures and messing around within them, finding their beauty, their intent and their limits. It is not a complete abandoning of herself that occurs in "A Due Voci's" images: what we see is the Rita-ego merging with Bayard's drowned self, and enjoying the paradoxical combination. The diptychs and triptychs of "A Due Voci" read like complicated equations. Rita liked this complexity; it was always her way of living. It seems to me that she wanted to both become Countess Castiglione and Bayard and, in an egomaniacal reversal that defeats chronology, have them become her. This sensation of exchange across time, gender, age, and other defining and confining differences stimulated and satisfied Rita's creative spirit.

This body of work is about communication between artists. Rita is not only posing the question to the viewer, but she's also asking Bayard or the Countess Castiglione or Mapplethorpe, "So what do you think of this: a seventy-year-old woman with loads of self-confidence has occupied your idea?" It's more than a reverent conversation; it's also an artistic coup, an aesthetic takeover executed with poignancy, empathy, and play. To place herself within works of art and to place works of art within herself: this is the ultimate act by one who loved art.

*Kim Waale*
Syracuse, N.Y. 1999

PETERSON AFTER "A DUE VOCI"

I don't remember the first time I met Rita, but I have distinct memories of good times with her while we were both graduate students at Syracuse University in the late 1970s. Although I had studied fine art as an undergraduate, I had never lived as an artist, as Rita did. Her studio, located above the storefronts of a quaint town outside Syracuse,

brimmed with books, art, objects, food, and drink. Here she shared her enthusiasm for art and life with a few younger graduate students, challenging us with her unorthodox ideas and entertaining us with slide/sound shows that frequently included the requisite Beatles song "Lovely Rita."

Rita's extensive series of self-portraits reflects both her wide-ranging interest in art and her compulsion for self-examination. Although she is primarily a photographer, she does not limit her historical references to photography. She embraces easel painting and vernacular photography, as well as art photography, as sources for her picture making. Painters from Bellini to Warhol have had their work seized for her playful interludes. Photographic references, however, are among the most vital for her work. Her recreations of images by nineteenth-century photographers such as Bayard, Nadar, and Gardner are particularly haunting and spiritual. Perhaps the "antique" quality of these images evokes a more intuitive reading and experience of the pictures for her.

Self-portraiture naturally involves a marked degree of self-consciousness. But Rita's self-consciousness is a tool for her own enlightened self-awareness, a trait that, in an artist, can only make for deeper and more meaningful art. Most artists, in fact, have multiple guises, allowing them to work in different media and on different projects at the same time. Rita addresses the concept of multiplicity head-on with the show-stopping pair of pictures "After Mapplethorpe," in which she is depicted as both a man and a woman. It is a tour-de-force of androgyny and gender-bending that is equaled only by the inspiring pair of pictures Robert Mapplethorpe took of himself as both female and male.

To elicit my thoughts, Rita sent me a book dummy of images, which included a few blank pages for pictures she had not yet made. Placed opposite the pieces she would be working from, they were hastily marked, "to be taken." I became intrigued with both imagining the pictures that were "to be taken" and the multiple meanings of this phrase. I joked with myself that maybe the pictures had actually been in place, but someone had "taken" them out of the book. More seriously, I thought of the phrase as an unconscious reference to Rita's emotional investment in both the individual pictures and the project as a whole. That is, "to be taken," or "to be in love," signaled her state of mind and heart, being thoroughly consumed with this creative act of art making.

Knowing Rita's energy and drive, I could think of no better characterization of the way she lives her life.

*Christian A. Peterson*
Minneapolis, Minn. 1997

Before I ever met Rita Hammond, I saw two of her self-portraits hanging in the house of a mutual friend, the one after Nadar of the mime dreaming and the other after Nijinsky as Petroushka. Each portrait hung separately from the other, each unaccompanied by the image to which it was responding. After seeing them on more than one occasion, I confess, I did not want to meet the artist. I was uncomfortable with the particular trope of self-representation and also uncomfortable with the network of allusion: I don't like old, sad clowns, and, though I had certainly heard of both Nadar and Nijinsky, they were only vague figures from what had always seemed to me an unpleasant moment or movement in the history of twentieth-century art. Here was an artist apparently identifying with her modernist predecessors and thus taking up the posture of modernist alienation, an alienation that extended in part from their self-awareness.

Inevitably, though, I met Rita Hammond and encountered an artist who was indeed part modern but who was also part postmodern in disposition. And it is this particular point that I'd like to take up. As the fuller range of her artistic acts suggests, Rita has not just one artistic posture, but many postures.

On the one hand, she has the modernist sense of the great, individual artist and the singular self as well as a seemingly rare respect for the long tradition of such artists. On the other hand, she has little anxiety about her relationship to that tradition, neither a sense of alienation from it, as I sensed in the Nadar/Nijinsky pair, nor a serious desire to compete for a place in it. Rather, the photographs seem to show a kind of nonthreatening interaction with tradition, in which the self is really not at stake at all. Indeed, this volume is not about who the artist is so much as where the artist may variously locate herself; not about the artist's singular subjectivity, so much as the artist's multiple possibilities for subjectivity.

While it gathers together a collection of self-portraits, this volume puts into question the notion of self-portraiture at the end of the twentieth century. Here we have an artist representing herself always in playful imitation of the other, always in the guise of the other, always with the representational devices of the other. There is no originality here. But whereas that might have been a criticism fifty years ago and even more recently, it is not today. What's wonderful about this work is that the self is not limited to one representation that finally defines the artist to the world and to history, but is, rather, free to explore various possibilities for selfhood in an expansive jaunt through history.

Rita sees herself not only in the moderns—Munch, Beckmann, Nadar, Nijinsky—but also in the Augustans, the Victorians, and the postmoderns. We need only juxta-

pose the earliest source image with the latest to sense the range of this artist-self. She is not only Jean Chardin blowing a bubble but also Robert Mapplethorpe dragging on a cigarette. This latter work is to me one of the most interesting and one of the most successful. While the Chardin is interesting for its conventionality and its country quietude, the Mapplethorpe is interesting for its radicalness and urbanity. In traveling from Chardin to Mapplethorpe, we travel not only across two centuries and an ocean, but also across the political spectrum, from the French pastoral to the American metropolis.

Rita's response to Mapplethorpe successfully repeats the uncanniness of gender identity. Mapplethorpe represents his nakedness as feminine, or obversely his femininity as naked, and his masculinity as clothed and thus calls attention not to the fictions of gender but to the fact that gender is always both familiar and unfamiliar, the fact that neither the naked body nor the clothed is the privileged mark of gender. It is, finally, this notion of the uncanny, in which the familiar is mixed with the unfamiliar, that perhaps best describes this volume. In any repetition there is always a degree of difference, even in photographic realism.

*Michael Davis*
Syracuse, N.Y. 1997

## NOVAK AFTER DERRIDA

### THE FRAME OF REFERENCE

*The presence of the original is the prerequisite to the concept of authenticity . . . that which withers in the age of mechanical reproduction is the aura of the work of art. This is a symptomatic process whose significance points beyond the realm of art. One might generalize by saying: the technique of reproductions detaches the reproduced object from the domain of tradition. By making many reproductions it substitutes a plurality of copies for a unique existence.*

—Walter Benjamin, "The Work of Art in the Age of Mechanical Reproduction"

What, then, is the status of these words—this brief extract drawn from Benjamin's essay? Originally, these phrases served as central thesis in Benjamin's reflections on the end of originality in art. The advent of photography, Benjamin argues, puts a period to that long epoch during which the artistic image laid claim to authenticity, to the aura of the sacred object: "the instant the criterion of authenticity ceases to be applicable to artistic production, the total function of art is reversed. Instead of being based on ritual, it begins to be based on another practice—politics." Such a shift con-

stitutes, for Benjamin, a unique opportunity—opens the possibility of confronting the aestheticized politics of fascist Germany with a politicized aesthetic of and for the masses.

What is the effect—it is my point to wonder—of wrenching Benjamin's words from their original context and resituating them here as a commentary on a book conceived as a series of quotations? To whom, in short, do these words now belong? Do they retain their integrity—remain the property, so to speak, of Benjamin's intention? Or are these words—thus recited and re-sited—now mine, a part of my own invention? Can I lay claim to them? Or is the very idea of laying claim, by means of such citation, laid to waste?

This series of questions, indeed the whole of this elliptical rumination, is itself of course a sort of citation. It is an attempt, however crude, at impersonation, at appropriating a style, a methodology, a thematic, a signature—the signature, moreover, of a writer much interested in Benjamin, a writer whose work in this particular vein might well be said to derive from this particular Benjaminian text. Acknowledged or unacknowledged, successful or not, such an effort at impersonation again resituates that text, reframing it as a quote within a quote. Given that even such limited concentricity serves to open, theoretically at least, a kind of infinite regress, a potentially unchartable chain of further associations and allusions, what of Benjamin remains? Although his presence here is in some sense definite—his words, after all, are quoted verbatim—that presence can't really be said to govern the whole of this open-ended series, to anchor the meaning of even his own words. Benjamin's presence, then, even in his own words, is spectral, a kind of haunting—a being haunted, as well, by the spectral presence of a host of others. And if this is true of Benjamin, is it not true of me too? As I sit here sifting possibilities, struggling with syntax, more or less mysteriously drawing meaning from within myself, am I not somehow effacing myself, turning myself into a sort of ghost? Am I not also, however, in thus losing myself, opening myself up to others, the presence of the other? What is lost in such a process? What is gained? And if I should attempt to own this discourse, by appending a signature, whose name should I use?

*Phillip Novak*

Syracuse, N.Y.  1998

# She Who Laughs Last...

ANN M. RYAN

Throughout the course of her thirty-six years as a photographer, Rita Hammond explored subjects as varied as the bedroom of Thomas Jefferson, the art of Picasso, and the architecture of the New Jersey coast. She worked in isolation, documenting natural artifacts and social landscapes; she worked in collaboration, exploring the way relationships evolve and how faces change. It is not surprising that her art has evoked responses as varied as her topics. Critics have praised Hammond's visual insights as well as her clever use of art history as both subject and medium, while audiences have characterized Hammond's work as being at once poignant and outrageous, biographical and communal, nostalgic and postmodern.

It is equally true that amidst all this variety, Hammond has spoken in a remarkably consistent voice. Throughout her career, and especially in the work collected in this volume, Hammond has relied upon her sense of humor as a frame for interpreting the world of art and for responding to the world around her. Even in a photograph as haunting as her resurrection of the drowned Hippolyte Bayard, Hammond is aware of the performative value of the guise she has assumed and of the humor implicit in it, recalling, after all, that Bayard's "suicide" is itself a dramatic posture. And if we are not amused by Hammond's impersonation of Bayard, we are nonetheless made aware of the instability of identity, the potential for radical transformation that marks all comic performance. In this respect, Hammond's photographs, particularly those in "A Due Voci," create a theatrical performance space where she invites her audience to be entertained, or at the very least, dares us not to be. As Hammond assumes the identity of the various artists and celebrities who attract her, she becomes much like an actor in a tableau vivant.[1] Hammond is not, however, interested in precisely recreating the original; instead, she draws our attention to the originality of her own performance. Each photograph seems to emerge from behind a theatrical curtain, revealing Hammond at play. And like the tableau vivant, Hammond's art is a pro-

---

1. A tableau vivant is an interpretation of a famous work of art performed by live actors, the goal of which is to reproduce the original faithfully. In the nineteenth century, these performances were frequently staged at social events (i.e., balls, parties, etc.). In *The House of Mirth*, for example, Wharton's main character, Lily Bart, experiences an epiphanic moment of self-revelation while she performs in a tableau vivant. Hammond seems to be aiming for a similar union of theatrical performance and personal reflection in "A Due Voci."

foundly social event; she wants her audience to play as well. Despite the egoism evident in her self-portraits, Hammond is, nevertheless, ready to work for the pleasure of the viewer. It would seem that of the many voices Hammond employs in *A Due Voci*, at least one intones, "Let me entertain you." Hammond willingly and literally becomes a clown in her work, a role that discomfits traditional notions of the artist as having refined sensibilities and privileged perceptions. Hammond is less a performance artist, seeking to confront, instruct, and expose her audience, than she is an artist eager to perform. Hammond flouts the staid and serious mystique that can, at times, surround the world of art. It is this aspect of Hammond's work that resonates most consistently with members of her audience who embrace not simply the humor of her photography, but the bravado that often accompanies it. Hammond will be no preacher in her work, nor will she lay claim to inflated artistic ambitions. Like Prospero at the end of *The Tempest*—one of her favorite plays—Hammond seems to declare that her only object "was to please" (epilogue, 13).

Yet Hammond's art, like Prospero's magic, is hardly so innocent. In claiming pleasure as a primary value in her work, and humor as one of her preferred media, Hammond evokes the discourse of contemporary feminism. Rita Hammond came into her own as an artist in the midst of the feminist revolutions of the late 1960s and early 1970s. At the time, feminist theorists, writers, and artists were not only in the process of confronting the social, historical, and political alienation of women, they were also exploring the nature of sexual identity, the gendered structures of language, and the promise of a liberated feminine voice. In effecting these many visions and revisions, feminist writers frequently relied upon the metaphors—and even the practice—of humor. French feminist Hélène Cixous in particular idealized the possibilities of female laughter by making it an expression of the utopian language of the "New Woman." She writes, "A feminine text cannot fail to be more than subversive . . . to smash everything, to shatter the framework of institutions, to blow up the law, to break up the 'truth' with laughter" (1981, 258). Hammond recognizes in her art what Cixous dreams of in her philosophy: that humor represents and enacts the power to redefine relationships and identities; and that humor is at once the voice of the historically privileged and the weapon of the traditionally marginalized. Hammond feels free to be both. Perhaps the greatest testimonial to her feminism is Hammond's absolute confidence in her ability to be male or female, clown or victim, Picasso or Marilyn Monroe. All of which seems to Hammond to be a remarkably good joke.

Hammond cultivated her artistic vision at a time when the laughter of Medusa, the language of jouissance, the cackle of hags, even the mad laughter of the hysteric, had

become dominant metaphors of female power and female history.[2] Hammond dismisses these characters as metaphors; instead, she embodies them in her art. As Hammond develops artistically, we see her evolve from portrait artist in her early photographic work (as in "Celebrity"), to playful art critic in "Hammond Canonized," to fully matured artist in "A Due Voci." Emblematic of her coming of age as an artist is Hammond's awakening "sense" of humor as a primary dimension of her work. In discovering and representing her authority as an artist, Hammond transforms her art into a site for pleasure, her own pleasure in particular.

Hammond's sense of humor emerges out of a history and an environment not always sympathetic to laughter in women. The cultural history of humor, from Jonathan Swift to Oscar Wilde, Lenny Bruce to Richard Pryor, seems to be a record of male writing and performance. Frances Gray writes, "While we see laughter as social, we also cherish the conviction that each individual's sense of humor is unique, as private and as special as our sexual nature. Humourlessness is thus a double burden, rather like barrenness in the Old Testament, a failure both social and personal. And like barrenness, it's assumed to be primarily a woman's problem" (1994, 5). The myth that women are by nature serious and by training humorless is ratified by Sigmund Freud in *Jokes and Their Relation to the Unconscious.* Freud (1960) argues that humor is fundamentally aggressive and, therefore, naturally masculine. According to Freud, the woman has two possible roles in the drama of humor: censure the male's desire for humor, which would be a sign of her own repression; or accept the joke willingly, a confirmation of her desire for the male. Nowhere does Freud imagine a feminine laughter occurring independent of male provocation or desire.

In response to both a cultural history that seems dominated by men and Freud's diagnosis of that history, some feminist writers have suggested that women's humor is, in fact, so profoundly different that it has been mistaken for anger, grief, madness, or even sympathy. Women seem humorless, according to such a reading, because their humor attends to other purposes—creating community or affirming humanist values—than those that occupy male humor. Despite the credible insight that allows writers such as Louisa May Alcott and Anne Bradstreet to emerge as humorists, there is still something vaguely apologetic about these readings. Unable to point to the female Mark Twain, our literary critics offer up Harriet Beecher Stowe as an alternative. The options for a female sense of humor seem radically narrow:

2. In addition to Cixous's use of the Medusa as an imaginative trope, several other prominent feminist writers and philosophers rely upon the language of humor to illustrate their claims. Luce Irigaray, for example, articulates the female body apart from its inscription in phallic history, giving voice to the "multiple" feminine experience of jouissance. Mary Daly, however, imagines female laughter in slightly more political terms when she theorizes about the power of the crone to liberate the female voice.

women may laugh to please men, they may laugh as men, or they may laugh in such a "female" way that their sense of humor disappears from the cultural radar entirely. Rita Hammond dismissed these options and found in her art a better alternative.

Hammond's sense of humor permeates her art, and it is wholly original and unembarrassed, unrestrained and self-satisfied. Hélène Cixous imagined the laughter of the "New Woman" to be an apocalyptic signal of a brave new world, a sign that humanity had finally transcended the binary systems, such as language and law, of which gender is the most visible manifestation. She writes, "You have only to look at the Medusa straight on to see her. And she's not deadly. She's beautiful and she's laughing" (1981, 255). In *A Due Voci*, Hammond achieves this vision of the self-defined and self-generating woman, yet without also abandoning history or sacrificing the luxuries of masculine culture. Hammond's laughter is certainly a victory, in part because she never feels compelled to defend it. In her photographs, Hammond occupies all positions: she is joker and target, man and Medusa.

One of Hammond's earliest images illustrates the extent to which she not only retains the binary systems of gender and language, she also enjoys playing with them. In this photograph, taken from outside a gallery at the Museum of Modern Art, an elderly lady dressed in sensible shoes, stylish suit, and a string of pearls looks intensely at a photograph hanging on a wall. The exhibit displays the works of Alexander Rodchenko, Laszlo Moholy-Nagy, and Andre Kertesz, respectively, a socialist revolutionary, an abstract experimentalist, and a left-bank bohemian. What the old woman sees, or what she may fail to see, is not available to the viewer. Her spine is curved and her head is bent, making her look like a living question mark. Above and behind her left shoulder is Rodchenko's portrait of the revolutionary poet Vladmir Mayakovsky, who seems to be staring ferociously and directly into Hammond's lens.[3] Poised outside the gallery space is a security guard, also looking pointedly ahead, and equally unaware of the old woman. In this context, Mayakovsky's disembodied head becomes a clichéd version of contemporary art—at once abstract and unrelentingly obvious, angry and male, all intellect and no fun—while the figure of the guard seems to project the stolid and unimaginative nature of all institutionalized order. The old woman stands between representations of law and revolution, ignored by them both, and apparently content to stay that way. With her bent and wondering body, she cannot be wholly bourgeois, as Mayakovsky may claim. Nor is she clearly obedient, as the guard may assume; she has, after all, entered a gallery full of radicals

3. Vladmir Mayakovsky was one of the leading poets of the Russian Revolution, and a member of the Russian Futurists, a collection of artists and writers who worked to liberate the arts from bourgeois taste and academic traditions. In his poetry, Mayakovsky worked to assault conventionality and to surprise his audience. Mayakovsky committed suicide in 1930.

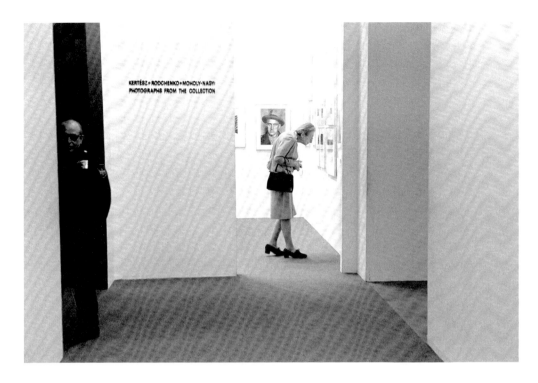

Woman at MoMA

and outcasts. In this image, the source of the humor is the elderly lady, who keeps her own counsel amidst the demands of masculine authority and artistic rebellion.

Hammond's portrait, however, is not simply a satire of a patriarchal art establishment; she also sympathizes with an artist whose work is being, quite literally, overlooked. The old woman stares at the wall, and Rodchenko's poet looks at the camera. The two figures oppose each other without ever realizing that they are in contention. The old woman looks so carefully at the artwork that she misses the big picture, and the "big picture" of Mayakovsky fails to connect with the only audience in the room. In this encounter—between "MoMA and grandma"—neither party is entirely satisfied, yet neither is completely disappointed. The modern artist has his sense of alienation confirmed, while the elderly lady spends a lovely day at the museum. Inasmuch as Hammond exposes these lapses and oversights, she balances her irony and her insight equally between the frustrated artist and earnest old woman. As an artist, Hammond sympathizes with the fate of the male photographer, whose work is misunderstood and misread; as a fan of both old ladies and sensible shoes, she enjoys the innocent appreciation of the elderly woman. Here, then, Hammond identifies with both male and female, while the pleasure of the moment is clearly all her own. In this photograph we see all the fierce potential of a "masculine" tradition of satire, without any of the anger that attends it, all the sympathy that an "other" sense of women's humor claims, without the anxiety that often surrounds it. Hammond's

sense of humor does not joyously detach her from the situation, and thereby from the ability to critique it, nor does her humor inscribe her in a fixed position, thereby limiting her ability to play.

To say that Hammond did not represent feelings of rage or marginalization, however, is not to say that she did not have them. The humor present in the photomontages, and especially in "A Due Voci," emerges through the lived history of a fully matured female artist. In the late 1960s and early 1970s, Hammond began her career as a "serious" photographer during the radical transformations of the women's movement. Hammond experienced her own artistic and sexual awakening at a time when the culture was being transformed by a feminist agenda. In Cazenovia specifically, the Women's Writers Center was attracting to the village some of the most notable artists, intellectuals, and political figures in the country: Anne Sexton, Ishmael Reed, Adrienne Rich, and Ralph Ellison, among others. As the portraits contained in this volume demonstrate, Hammond becomes a fan not simply of the individuals she encounters, but also of their emerging celebrity. In essence these images document Hammond's own fascination with extraordinary individuality. The portraits are loving, respectful, and even original in their insights. Yet, if, in "Celebrity," there is no sign of the dialogue—between viewer and viewed, male and female, the past and the present—that will distinguish Hammond's later work, there is ample evidence that Hammond is at least listening to the world around her. In one of her later pieces, a three-dimensional box that reflects upon Hammond's life in 1944, she quotes from Adrienne Rich's poem "I Dream I'm the Death of Orpheus": "I am a woman in the prime of life with certain powers and those powers / severely limited / by authorities whose faces I rarely see" (1973, 1229). Hammond encounters Rich in the early 1970s, and it is an experience that allows her to revisit and revise her past, and to pose herself and her art against those censoring authorities. Hammond's early career as a "serious" artist, that is, as an artist who earnestly and accurately documents the world, allowed her critical voice to emerge. Toward the end of her career, Hammond would no longer allow the anonymous or unseen authorities of Rich's poem and her own past to remain unnamed or unexposed. With an almost martial ambition, she confronts the "great masters" in "Hammond Canonized," and in "A Due Voci" she claims their privileges: genius, power, and beauty. Yet Hammond's accomplishment in these two bodies of work seems less like a victory than a homecoming. In these images, Hammond projects her own identity and authority as a woman, and just as Cixous predicts, Hammond's success is embodied by her sense of humor. In both of these collections, "She's beautiful. And she's laughing" (Cixous 1981, 255).

In "Hammond Canonized," Hammond steps from behind the camera and enters not only the gallery space she had previously observed, but the frame of the photograph as well. In this series, Hammond inserts an image of herself within a painting and effectively redefines the formal composition and theme of the piece. Hammond's character in these works is neither distant and ironic nor overwhelmed and impressed. She enters the paintings of Vermeer, Campin, Cézanne, and Picasso with the same casual confidence that she would have walking into a coffee shop or sitting down at a bar. Although she does not appear in the costume of a clown, as she does in "A Due Voci," Hammond is very much acting the part of one. In each of these collages, Hammond courts our seriousness with her charm, while she also disconcerts the sanctity of the paintings she inhabits. Like a clown in a circus, Hammond becomes in these works of art an unpredictable element: rollicking when she should behave; intruding when she should be quiet; and surfacing when, where, and however she pleases. Hammond deflates the pretensions of "great art" with her own banal presence, while she also excites our sense of dangerous possibilities. Where will she go next? And what will she do when she gets there? While Hammond is something of a transgressor, she does not seek to violate or assault the world of the painting; she wants, instead, to play in it. In many ways, Hammond embodies the type of healthy confusion Mikhail Bakhtin idealizes in his conception of Carnival. During the medieval carnival, the rigid codes and structures that define the social order are lifted. Clowns become the embodiment of Carnival as they represent, in acts of parody and moments of chaos, the alternative possibilities beneath the surface of the commonplace. Bakhtin writes, "The utopian ideal and the realistic merged in this carnival experience, unique of its kind. This temporary suspension, both ideal and real, of hierarchical rank created during carnival time a special type of communication impossible in everyday life" (1968, 10). Hammond's images likewise suspend the rule of order by introducing into the imaginary world of canonical art the presence of a real woman. What more absolute sign of inversion and insouciance could there be than for a rumpled Rita Hammond to walk in on the ballerinas of Degas? In fact, many of these images evoke the liberating excess of Carnival. Bakhtin's description of Carnival seems to be precisely the experience Hammond enjoys in the photomontages: "Carnival is not a spectacle seen by the people; they live in it, and everyone participates because its very idea embraces all the people. While Carnival lasts, there is no other life outside it. During Carnival time life is subject only to its laws, that is, the laws of its own freedom" (7). In her photomontages Hammond "lives in" the space and likewise is subject to little else but her own desires. Hammond sips nectar with Bellini's gods and swills vodka with Hogarth's rake; she becomes the head of the

Devil for Hieronymus Bosch, and she's hanging out with the courtesans of Toulouse-Lautrec. And just as Carnival "embraces all people," Hammond's intrusion upon these works of art seems to affirm that they are in fact accessible to us all.

If Bakhtin envisions Carnival as a temporary suspension of law and reason, however, Hammond does not. She is not simply touring the works of the great masters; she has become a participant, a permanent fixture: on St. Joseph's bench, in Vermeer's studio, at Hogarth's bacchanal, around Cézanne's card table. Likewise, Hammond's desires, appetites, and pleasures, all amply on display in this series, will not be forgotten or regretted when the carnival ends. Certainly the surprising contrasts Hammond creates between herself and the world of high art are one source for the humor of these images. In addition, Hammond thrills us with the sensation of taboos being broken, of appetites being indulged, of racy stories being told. We become the conspirators in Hammond's transgressive romp. Freud argues that hostility and sexual desire cannot ultimately be repressed. If they are not expressed in sex or violence, they are sublimated, emerging as madness, art, dreams, or, finally, as humor. In transgressing upon and playing with these artistic icons, Hammond satisfies her deepest desires, and she expresses that satisfaction as humor. In Shakespeare's *As You Like It*, Rosalind warns, "Make the doors upon a woman's wit, and it will out at the casement. Shut that, and 'twill out at the key hole. Stop that, 'twill fly with the smoke out at the chimney" (4.1.138–41). Hammond's work illustrates the inevitability of female desire and its necessary expression in humor. Hammond demonstrates that a woman's sense of humor cannot be silenced or mistaken for something else. In the photomontages, Hammond has constructed a world where a woman's wit and her desires are both free to play.

The space that Hammond constructs in the photomontages is very much akin to the utopian world that Cixous imagines as a consequence of feminine revolution. The spirit of jouissance, of an ascendant, sensual, and ubiquitous female pleasure, dominates these images. However, Hammond is not, ultimately, an idealist, nor is she inspired by utopian worldviews. The true test of Hammond's sense of humor is how well it endures the pressures of politics, of history, and of gender. In "A Due Voci," Hammond expresses her voice within and throughout the experience of male and female, young and old, beautiful and beaten, and in so doing she achieves an authority not necessary and not available in a utopian fantasy. Hammond responds to a group of original portraits of Marilyn Monroe by Eve Arnold, Andy Warhol by himself, and Pierrot (Charles Deburau) by Félix Tournachon (Nadar), among others. This series of portraits and self-portraits, whether of historical or imaginary figures, communicates for Hammond the urgency of real life: the limitations of identity for the Countess de Castiglione, the pain of loss for Hippolyte Bayard, the problem of gender

for Louise Brooks, and equally the problem of its representation for Robert Mapple-thorpe. In her "re-visions" of these originals, Hammond employs a great deal of wit, and her insights are inherently clever and playful. However, although humor is both the means and the end for Hammond in the photomontages, confirming a "self" serving and liberatory pleasure, Hammond's sense of humor in "A Due Voci" does not transcend reality. In her response to these original portraits, Hammond does not use humor to evade their implied histories, but to negotiate with these histories instead.

In "A Due Voci" Hammond's sense of humor is fundamentally critical. She positions her revision beside the original in order to highlight the mutability of the realities it contains, while simultaneously claiming the permanence of her own identity. For example, in Alexander Gardner's portrait of Lewis Thornton Paine, the doomed conspirator in Lincoln's assassination loses some of his tragic magnetism once Hammond affects his attitude and posture. To the extent that Hammond's images are performative and repetitive, she is, like a mime, engaged in acts of parody, reducing the original to a series of gestures, expressions, and poses. However, unlike a mime, Hammond's own face and experience are not erased by the parodic act. Therefore, what prevents Hammond's response to Paine from being a simple impersonation—a kind of visual and linguistic pun, countering this "Paine" with her own—is the critical connection she establishes between her own potentially revolutionary and violent desires and those of the would-be killer. Hammond leans against the wall, a captured felon; unlike Paine, her chin is slightly raised in what seems almost to be a gesture of defiance. What would it mean, the pairing seems to suggest, for Rita Hammond to be caught in the act of assassination? The question, like the paired images, has two voices: at once imaginary and historical, humorous and tragic, playful and deadly serious.

Hammond sets the stage in "A Due Voci" for both her own sense of humor and her sense of self to emerge. Central to this process is a confrontation with precisely those gender roles that, for Freud, structure the experience of humor. Throughout this series of images, Hammond exposes bodies, male and female, her own and others, occasionally stripping them down to the bare bone. Hammond tacitly accepts Judith Butler's premise that "there is no gender identity behind the expression of gender; that identity is performatively constituted by the very expressions that are said to be its results" (1990, 25). In "A Due Voci," Hammond's gender appears at times to be little more than a costume; Hammond's masculinity seems inscribed in the tilt of Beckmann's hat, while her feminine self competes with Mapplethorpe's girl to see who's the prettier. Still, Hammond can only go so far with Butler's claim that gender is in the eye of the beholder. Throughout "A Due Voci," Hammond insists upon the reality of the female body and of the social and political histories written upon it.

Ultimately, Hammond's performance of gender in these images does not question the reality of gender as much as it illustrates its limited and limiting history, especially for women.

Hammond begins to explore that limiting history with her response to Virginia Oldoini, the Countess de Castiglione (1837–1899), a notorious Italian courtesan and spy who attracted admirers and enemies in equal proportion. Castiglione became fascinated with the emerging art and science of photography, and she used the skills and the studio of Pierre-Louis Pierson to project herself into a number of female roles and attitudes: The Queen of Etruria, Lady MacBeth, the biblical Rachael, the figure of Vengeance, the Marquise Mathilde. Castiglione's passion for self-dramatization is in many ways a precursor to Hammond's work in "A Due Voci." Yet while the countess affects the same bravado as Hammond, she cannot escape the deeply inscribed roles she inhabits. Despite the authority Oldoini demonstrates in recreating herself before the camera, she ultimately recapitulates many of the myths and images that confined her.[4] Her photographs illustrate virgins and harlots, goddesses and fashion plates, tragic heroines and saintly martyrs. The images are original; the narratives they represent are not.

Hammond's response to Oldoini's *Scherzo di follia* (Games of Madness), inspired by Verdi's opera *Un ballo in maschera*, strips the countess of the cluttering personality and drama that inform the original and replaces them with Hammond's own bare and fleshy body. Hammond effectively liberates the Countess de Castiglione, not from gender, since the presence of the female body is so pronounced in the photograph, but from the operatic narrative that seems to contain her. Hammond simplifies the original representation of the countess, eliminating the ornate costume, the bouffant hair and jewels, replacing this highly coifed expression of feminine allure with Hammond's own wild and wrinkled aspect. Obviously, there is a kind of parodic and satiric content to Hammond's response; either Hammond or the countess may be the object of humor. On the one hand, Hammond exposes herself, with her bad perm and her thick arms, to a direct comparison with the legendary beauty, while Hammond's realism, on the other hand, unmasks the highly artificial identity of the Countess de Castiglione. Ultimately, however, Hammond complicates these binary roles—old woman vs. young, beauty vs. crone—laid out for both herself and Oldoini. In her version of *Scherzo di follia*, Hammond looks not directly into the camera as does

4. Castiglione was banished from the French court after being accused of plotting against the life of the emperor, who was for a time her lover. Castiglione appears to have been innocent of all charges, but she was nonetheless disgraced. According to Apraxine and Demange, "Disillusioned in her political efforts and devastated by the loss of her beauty, the Countess led an increasingly reclusive life . . . She went out rarely, mostly at night, heavily veiled, and met with only a few intimates. . . . She died alone in Paris on 28 November 1899" (2000, 16).

the countess, but off into the distance. Hammond rejects the polemical options authored, as Adrienne Rich has described elsewhere, by unseen authorities (1973, 1229). In Oldoini's original, the countess confronts her status as visual object by addressing her gaze directly to the camera. In describing *Scherzo di follia*, the editors of *"La Divine Comtessa": Photographs of Countess de Castiglione* write, "The eye, reduced to its voyeuristic role, becomes a symbol. The sitter's identity is hidden behind the improvised mask, and the image acquires a striking timelessness. Since the 1960s it has been an icon of photography" (Apraxine and Demange 2000, 183). Hammond insists that this image is also a particular symbol of the woman's experience as viewed object. In her sidelong glance, Hammond offers an alternative to the tense confrontation between viewer and viewed, male and female; Hammond's eye is occupied elsewhere, engaged in some "other" spectacle. As a consequence, some of the humor of this pairing emerges from Hammond's lack of interest in the "mad" game that she is supposed to be playing.

In her response to Eve Arnold's portrait of Marilyn Monroe, Hammond's sense of humor, implicit in her duel with Castiglione, is perhaps more obvious. Hammond effectively sets herself up to be the target of humor when she sits beside the voluptuous Marilyn, exposing to the public eye what has traditionally remained hidden: the nude body of an older woman. In this case, however, old woman and young beauty are less in contention than they are in conspiracy. Arnold's portrait seems to be a spontaneous shot of the actress during preparations for a photo shoot. As the partially nude Marilyn sits in a wire-back chair, an arm emerges from behind a screen to fix Monroe's hair. The arm appears from out of nowhere, and seems attached to no one in particular. It is clear, however, that it is the arm of an older woman. In this original portrait, the photographer has captured the process of creating the sexual commodity known as Marilyn Monroe. This unseen woman becomes an agent in realizing the desires of studios, of fans, and of the culture at large. To the extent that this older woman participates in the process of perfecting Monroe's image, she is complicit in the act of turning Monroe into a product; to the extent that she is older, and female, she seems in Arnold's photograph to have no choice, compelled, perhaps by the same economic and cultural imperatives that trapped Monroe herself. As Monroe turns toward the camera, looking over her shoulder, she reveals an exquisite back and curving waist. We can also see, just above the wrist of this other woman, Monroe's almost open mouth. Arnold captures the uneasy moment when Monroe shifts from being a subject with a voice, to being an object of desire. In juxtaposing Arnold's Marilyn with a portrait of herself taken by Ray Beale, Hammond completes and reverses this transformation, becoming a subject of desire, a kind of speaking body. She literally and imaginatively turns Monroe around. Hammond faces the camera

completely nude, and covers her own mouth with her own aging hand. It would be possible to argue that, by covering her own mouth, Hammond repeats the censoring operations represented in Arnold's photograph—reinforcing the victim status of Monroe—were it not for the fact that Hammond's image is remarkably funny. The picture of Hammond's nude seventy-year old body, assuming the form and aspect of Marilyn Monroe, is at once outrageous and inviting. Hammond's frank portrait is strangely sensual, perhaps because Hammond seems to be so comfortable in her own skin. Unlike Marilyn, who arches her back and covers her front, Hammond does not primp to meet the expectations of any audience. And if her hand is over her mouth, it is in order to keep her from laughing out loud. Hammond does not seem to be suggesting the possibility that inside every woman is a Marilyn Monroe; instead, she's liberating and sexualizing the laughing old woman who lives just beneath the surface of Monroe's soft exterior.

In "A Due Voci," Hammond presents her own body in a kind of striptease, beginning with a little shoulder in her response to Countess de Castiglione, some cleavage in her representation of the female Robert Mapplethorpe, continuing with the portrait of Hammond as the nude Marilyn, and culminating with the promised version of herself as Lee Friedlander (a photograph that invites Hammond to become utterly exposed). In these images, Hammond's body becomes an imaginative tableau upon which she writes her responses to the lives of her subjects. Frequently, that response is humorous. Hammond's sense of humor seems intricately bound to her body, and to the ability to represent her body without apology. Amidst all of the illusions, postures, and costumes in "A Due Voci," Hammond's body is an absolute and constant presence. Her breasts and stomach and arms and hair—records of her age and experience—become the counterpoints to various histories of pain, of loss, of sorrow, and of oppression. In essence Hammond's body becomes the punchline to the joke she's been telling in "A Due Voci," insisting that she has not been erased by history, romanticized by art, or objectified by popular culture. In disarming these oppressive processes and traditions, Hammond's sense of humor becomes a powerful expression of her authority. In assuming the clown's face of Petrouchka, Hammond recapitulates the effect of her body in these other portraits; that is, she suggests that beneath the artifice of paint and makeup there is a woman who chooses laughter as a viable defense against the world around her. Unlike Nijinsky's portrait, Nadar's image of Deburau, or Picasso's harlequin, Hammond is no sorrowful clown. These male artists assume the costume of the clown to reflect their alienation, their bitterness, or even a sense of their own impotence. For Hammond, her identity as a clown redeems her history as a woman; as a clown Hammond has the freedom to disrupt and to unsettle, and the power to satisfy repressed desires.

Hammond in Gap ad
The GAP logo is a registered trademark of The Gap, Inc. No affiliation with or sponsorship or endorsement by The Gap, Inc. is implied or should be inferred.

    Eventually, in "A Due Voci," Hammond will put her clothes back on. In an advertisement by the Gap clothing company, a caption beneath a photograph of Margaret Bourke-White declares that "Margaret Bourke-White wore khakis," suggesting presumably that the greatness of this woman's art is reflected in her correspondingly excellent taste in trousers. In a gesture similar to her work in the photomontage, Hammond steps into the advertisement and, by implication, into the role of Margaret

Bourke-White, making herself a mythological figure of fashion and art. Hammond stands in her apartment/studio, a space that for Hammond has been as hard to secure as Bourke-White's perch atop the Chrysler Building, and she insists upon her own authority. This photograph is one of the least mimetic and the most biographical in "A Due Voci," and it is also one of the most amusing. The Gap has a blanket policy that prohibits any reproduction of its advertisements; as a result, we were unable to present the diptych in its entirety. Although the Gap never had the opportunity to review Hammond's work, we cannot help but wonder what this corporate giant might have seen in her photograph. Hammond's image could suggest some confusion between herself and Bourke-White, or perhaps the Gap might have worried about the aesthetic or commercial implications of Hammond putting on—or putting down—their khakis. She would have relished either possibility. Hammond's self-promotion in the Gap advertisement communicates at once the achievement of her life and the power of her humor. The Gap may never have chosen Rita Hammond to be a symbol of its products and corporate ideology, but Hammond seems to suggest that the loss is all its own.

Against the processes that reduce women to objects of beauty and desire—in front of the camera, in literature, in art, and in the public eye—Hammond fills in the gaps, in some cases quite literally, with her own body. And our response to Hammond's portraits often is to laugh, affirming, perhaps, the alternative feminine reality—sensual, creative, and revolutionary—promised by Cixous's Medusa. There is an old Italian proverb, "He who laughs last, laughs best"; in *A Due Voci*, Hammond secures that position for herself.

# Loss and the Power of Art

One is tempted, of course, to look at *A Due Voci* and simply enjoy it: Hammond's inge-nuity, her play, her humor. For this reason, and because, relying as she does on audi-ence recognition of well-known images, Hammond clearly understands the enter-tainment value of the work, one is also tempted to read *A Due Voci* as pastiche, an uncomplicated and potentially vacant nostalgia. Identified by cultural critics such as Fredric Jameson as a central component of contemporary cultural production, pas-tiche is distanced, detached from history, and slight. As I hope to show, however, Hammond's work is neither detached nor in any way simply appropriative. On the contrary, *A Due Voci* is a deeply engaged work, dedicated to art and to history. Ap-pearing to be pastiche, the work of Rita Hammond is in fact deeply romantic. Ham-mond's parody and her romanticism are not at all conventional, but provocatively poised to comment on the function of imagination in art and in the construction of art history.

For Jameson (1994), pastiche is empty nostalgia. Contemporary texts characterized by pastiche present "a new kind of flatness or depthlessness, a new kind of superficiality" (9), which keeps us from "experiencing history in some active way" (21). Instead, Jameson argues, these texts function as escapes from history, and we consume them in order to gain merely a moment's pleasure, the "aha!" experience we share when we recognize an image associated with the cultural past. In other words, the *frisson* we feel when we experience pastiche (or when we create it, for that matter) is merely empty "random stylistic allusion" (18), a self-congratulatory, self-indulgent sensational quick fix:

> Pastiche is, like parody, the imitation of a peculiar or unique, idiosyncratic style, the wearing of a linguistic mask, speech in a dead language. But it is a neutral practice of such mimicry, without any of parody's ulterior mo-tives, amputated of the satiric impulse, devoid of laughter and of any con-viction that alongside the abnormal tongue you have momentarily bor-rowed, some healthy linguistic normality still exists. Pastiche is thus blank parody, a statue with blind eyeballs. (17)

While this influential view still predominates, the idea is complicated by more recent criticism that means to attribute a more positive value to pastiche. Ingeborg

Hoesterey, for example, offers a new reading of pastiche as engaged critical commentary. Relying on the work of Italian writer Salvatore Battaglia, Hoesterey (2001) provides a fascinating history of pastiche, noting its source in seventeenth-century Italy: "Literally 'pasticcio,' derived from Common Romance *pasta*, denoted in early modern Italian a pate of various ingredients—a hodgepodge of meat, vegetables, eggs, and a variety of other possible additions" (1).[1] Drawing examples from architecture, art and photography, film, and literature, Hoesterey does an admirable job of suggesting some possibilities for recovering postmodern pastiche as a valuable critical tool for understanding the culture, what he calls the "emancipatory potential of the intellectual pastiche" (29). Unlike Jameson, Hoesterey believes that pastiche engages history: "Today's intellectual pastiches are about culture as a process of meaning constitution; they reflect upon the historicity of aesthetic judgment and taste" (31). Indeed, Hoesterey wishes to redefine pastiche as liberating and as politically motivated, "a challenge to the canonization of the classical, whose material presence it problematizes as ideological" (24).

Perhaps a key element in Hoesterey's analysis is his insistence on the term *intellectual* as part of his categorization of pastiche (i.e., "intellectual pastiche"), since the phrasing suggests a consciousness, a political awareness, about the process initiated by pastiche. In an increasingly anti-intellectual culture, however, it is easy to sympathize with Jameson's concern that pastiche, because of its often empty allusion to images and events from the past, serves only to evade history (preventing us from understanding social problems as a part of real history). While art critics may be able to distinguish between pastiche (superficial) and "intellectual pastiche" (liberating), Jameson's suspiciousness seems helpful because contemporary culture does seem obsessively concerned with a kind of dehistoricized past. This preoccupation with representing mere tissues of a shared cultural past is marked, for example, in film adaptations of *The Brady Bunch*, *Charlie's Angels*, and *Bewitched*, and perhaps in the box-office smash hits of film director Baz Luhrman, who empties, one could argue, *Romeo and Juliet* and the Moulin Rouge of their historical and literary significances in favor of a purely sensory kinetic experience. While the experience of pastiche may provide immediate gratification, the limits of this kind of art lie in its failure to ignite thought combined with feeling, or as Jameson describes the loss of human connection to history, "the waning of affect" (1994, 15).

And yet, pastiche may be an important illuminating framework in which to study Hammond's work because, on a first viewing, we might well identify her work as merely allusive, or at least as drawing on contemporary obsessions with pastiche.

1. Hoesterey cites as the source of this derivation Salvatore Battaglia's *Grande Dizionario della Lingua Italiana*, Vol. 12 (Turin: Unione Tipografica-Editrice Torinese, 1984), 791.

How interested, really, is Hammond in drawing attention to the production of particular paintings and photographs? Doesn't Hammond's work rely primarily on the thrill of recognition? Hoesterey's revisionary commentary on pastiche is helpful here: On the one hand, Hammond's work isn't overtly political (as, for example, Cindy Sherman's photography is), and thus the new, more positive understanding of pastiche doesn't entirely capture our sense of Hammond's work. On the other hand, Hammond's work is passionately engaged, and Hoesterey's broader meaning of pastiche helps us to consider the critical and potentially liberatory nature of Hammond's art.

The status of pastiche—as political commentary or as trite allusion—is important, since we find our millennial selves doubtful of the value of "the real." As we gradually acclimate ourselves to technology's potential to resituate past cultural texts, photographic images often raise to the surface cultural anxieties (suppressed and repressed) about the nature of reality, about history, and about the value of that history to shed light on our present and future. For example, in the summer of 1990, the *New York Times* marshalled in a version of our contemporary play with "the real" in an article called "Ask It No Questions: The Camera Can Lie," which featured a photograph of Sylvester Stallone's Rambo and Groucho Marx joining Roosevelt, Stalin, and Churchill at the Yalta Conference. The image is reproduced in William J. Mitchell's book *The Reconfigured Eye: Visual Truth in the Post-Photographic Era*, accompanied by the following commentary: "the photographic falsifier holds up not a mirror to the world

*A New Cast for Yalta*
Paul Higdon / NYT Pictures

but a looking glass through which the observing subject is slyly invited to step, like Alice, into a place where things are different—where facts seem indistinguishable from falsehoods and fictions and where immanent paradox continually threatens to undermine established certainties" (Mitchell 1992, 190). As a body of work invoking history at the same time as it seems, in a strikingly literal fashion, to supercede history, "[undermining] established certainties," the images in *A Due Voci* compel us to engage conceptions of the status of the image in relation to history and the real.

Conceptually opposed to pastiche, conventions of romanticism are at the core of cultural understandings of the role of the artist. Hammond pointedly replays and revises some of the central tenets of classic romanticism, notably the artist's desire to imaginatively address discontinuities: between life and death (immortal art providing a bridge between them); between the past and the present (the hope "That in this moment there is life and food/For future years"); between youth and age ("The Child is Father of the Man"); between art and society ("Poets are the unacknowledged legislators of the World"); and between the artist and her audience (the poet "adopts the very language of [common] men").[2] To be sure, Hammond—at the time of working on *A Due Voci* a seventy-year-old Jewish lesbian adjunct instructor of art history—doesn't share much with the male titans we associate with the classic Byronic poet/heroes. Hammond is nonetheless a romantic iconoclast, revising some assumptions of classic romanticism while embracing others. Hammond's work engages issues central to romantic ideology, including the prioritizing of originality, the quest for immortality, the emphasis on the importance of solitude, and an abiding reliance on some form of egotistical sublime as the reward for that solipsism.

It is clear enough to see how Hammond comments on the romantic investment in originality as the basis of artistic genius: Hammond's obvious fascination with collaboration and dialogue parodies the romantic convention that the artist's genius is contextless, that in order to produce art, the artist's imagination needs to be liberated from all social bonds or restraint. Owning a license to follow creative stimuli at any cost, the romantic artist requires solitude and egotism to create art. Diverging from this model, Hammond appreciated the value of artistic community and the aesthetic and intellectual exchange these communities made possible. The diptych and the triptych thus function thematically as well as formally for Hammond, since the play between images in the "A Due Voci" series helps to promote dialogue, a conversation

2. The quotes are drawn, respectively, from Wordsworth's "Tintern Abbey," Wordsworth's "My Heart Leaps Up" (also the epigraph to "Ode: Intimations of Immortality"), Percy Shelley's essay called "A Defence of Poetry," and Wordsworth's Preface to *Lyrical Ballads*.

among images, among ideas, among artists and audiences. In this way, Hammond works against the romantic investment in solitude.

At the same time, the individual drive and romantic ego implicit in Hammond's work also seem to constitute its imaginative flair. Hammond's powerful selfhood exudes from every page of this volume. What Hammond does in *A Due Voci* is to blend these ideas; she grafts her ego—her romantic selfhood—onto an idea of artistic community, a notion of sympathy among artists. Indeed, relying on collaboration and dialogue, Hammond's interest in this sympathy is, in some sense, the source of her egotistical sublime. Of course, this is a paradox inherent in classic romanticism: that romantic egotism is fundamentally dependent on sympathy; that all romantic poets are deeply connected to others, and to the world. For John Keats, for example, artistic creation requires what he calls "negative capability," the ability to get outside one's self: "that is when man is capable of being in uncertainties, Mysteries, doubts, without any irritable reaching after fact & reason" (Perkins 1995, 1276).[3]

Paradoxically requiring sustained objectivity as well as empathy, art for Keats requires a negation of the self in order to occupy (and thus write poetry about) the position of the other, whether that point of identification be a child, an old man, a bird, or a natural setting. The centrality of empathy to romantic conceptions of artistic creation is echoed by Percy Shelley in his 1821 "A Defence of Poetry":

> The great secret of morals is love; or a going out of our own nature, and an identification of ourselves with the beautiful which exists in thought, action, or person, not our own. A man, to be greatly good, must imagine intensely and comprehensively; he must put himself in the place of another and of many others; the pains and pleasures of his species must become his own. The great instrument of moral good is the imagination; and poetry administers to the effect by acting upon the cause. (Perkins 1995, 1135)

The "A Due Voci" series exemplifies negative capability, in that on one level, Hammond negates her self in order to engage meaningfully with other artists' selves. Although both "A Due Voci" and "Hammond Canonized" boast enormous self-possession—the self-confidence required to enter into famous works of art—at the same time, Hammond calls attention to herself as a nobody, as an anonymous old woman somehow embodying the spirit of great art. For as much "chutzpah" as Hammond demonstrates in this work, she is equally a "schlep," to use the vocabulary Hammond

3. The term "negative capability" is taken from Keats's letter to his brothers George and Tom Keats (December 21–27, 1817). In a letter to Richard Woodhouse (October 27, 1818), Keats also coined the phrase "egotistical sublime," referred to above, by which he means Wordsworth's method of gobbling up the object of his reflection (the other), as opposed to negating the self in order to occupy the space of the other (Perkins 1995, 1286–87).

would have preferred. Like other romantic artists, then, Hammond paradoxically exercises egotistical sublime and negative capability, audaciously entering into great works of art while, at the same time, utterly submitting to these representations as other states of being. Hammond is self-effacing, drawing into relief not only the virtues of what she observes and reflects on, but also the empathy that allows her to enter into the spirit of other identities, other historical moments.

Part of the reason why the images in "A Due Voci" and "Hammond Canonized" work is that Hammond comes to stand in for a vast audience of those, like us, who want to imagine ourselves stretching beyond the limits of our anonymous lives. She's wrestling, as we all do, with mortality. Thus, it is not a coincidence that Hammond began *A Due Voci* in her mid-sixties, a time in her life when consideration of her age and her mortality may well have frayed the edges of her consciousness. Hammond's desires exceed notions of mere star power or familiar clichés about fifteen minutes of fame. *A Due Voci* suggests, instead, a more universal desire to enter into history, which Hammond does with humor and intelligence and pathos: Says Hammond, "I'm going to *be* Picasso."

In an essay I will discuss at greater length below, Cynthia Ozick claims the following: "To 'identify with' is to become what one is not, to become what one is not is to usurp, to usurp is to own" (1997, 87). I think Ozick raises important questions about artistic engagement, the extent to which artistic expression necessarily involves appropriation. A former professor of mine used to refer to Wordsworth's "environmentally incorrect" (read "exploitative") appropriation of the natural world for the sake of rendering memories as poetry (Tucker 1991). Certainly it would be possible to level such a charge at Hammond in "A Due Voci" and "Hammond Canonized." Hammond's imaginative address to past artists, however, is not in any simple sense appropriative—which might suggest that her work is fundamentally pastiche, in Jameson's terms—but deeply interested in the stories represented in, the stories behind the making of, and the possibilities for stories inspired by the source images in *A Due Voci*.

Indeed, taken as a whole, the work coheres in a way that separates it distinctly from pastiche. If pastiche is by most reports fundamentally ahistoric, Hammond's work strives to fill gaps created by history's neglect, resuscitating some of art history's stories, not only to bring to the surface poignant traces of historical loss, but also to invite her viewers through their own exercises in empathy to complete the stories she invokes. Suggesting that no image is able to exclude the personal histories of artist and audience, Hammond said as she looked over the images in *A Due Voci* just before she died, "Well, we all contribute, not just me" (Hammond 1999).

For example, Hammond explores her fascination with histories partially told—the historically underrepresented—in her dialogue with Bayard's "Self-Portrait as a Drowned Man." Hippolyte Bayard, bitter about Daguerre's usurpation of credit for the invention of photography, created a self-portrait accompanied by the following inscription, which he wrote on the back of the print as a "suicide note":

> The corpse which you see here is that of M. Bayard, inventor of the process that has just been shown to you, or the wonderful results of which you will soon see. As far as I know, this inventive and indefatigable experimenter has been occupied for about three years with the perfection of his discovery.
>
> The Academy, the King, and all those who have seen his pictures admired them as you do at this very moment, although he himself considers them still imperfect. This has brought him much humor but not a single *sou*. The Government, which has supported M. Daguerre more than is necessary, declared itself unable to do anything for M. Bayard and the unhappy man threw himself into the water in despair. Oh, human fickleness! For a long time artists, scientists and the press took an interest in him, but now that he has been lying in the Morgue for days, no-one has recognized him or claimed him!
>
> Ladies and gentlemen, let's talk of something else so that your sense of smell is not upset, for as you have probably noticed, the face and hands have already started to decompose.
>
> H. B., 18 October 1840
>
> (Gernsheim 1982, 69)

By linking his personal history (life and imagined death) to the public history of the invention of photography, Bayard accepts, or submits to, history's disregard for the unacknowledged great ones. At the same time, however, by projecting that loss into the realm of the aesthetic, Bayard ironically transforms a suicide, imaginatively completed in his inscription when he refers to his objectified self in the third person, into an immortal register of artistic possibility. Hammond chose to represent herself as Bayard in part as a response to this potentiality. She shared more with Bayard than just the sense of being overlooked. Her romantic quest for immortality, like Bayard's, relies on her address of the potential losses of personal and public histories, giving these real and fictive characters an opportunity to finish something they merely began. Hammond summarizes these possibilities well: "You end up completing something they can't" (1999).

Anne Frank Fonds—Basel\Anne Frank House—Amsterdam\Hulton Archive by Getty Images

From *They Would Be My Age Now*

Hulton Archive by Getty Images

Nowhere is the dialogue with stories of historical loss more affecting than in the series of photographs Hammond imagined as a triptych, *They Would Be My Age Now*.[4] Here, Hammond positions herself between familiar images of Anne Frank and Marilyn Monroe. In her imagining of herself as a connecting link between these images of Frank and Monroe, Hammond engages history by marking its losses. Wanting to call attention to the personal and historical wounds evoked by these portraits, Hammond initially wet the prints in *They Would Be My Age Now* and crushed them into balls, unrolling the images so that they appeared wrinkled, so that they would have what she termed a "bruised" look. While Hammond's fascination with Anne Frank partially stemmed from her sense that she looked like Frank when she was a little girl, Hammond was interested in both of these women because she knew that the particular tragedies of Frank and Monroe gesture with some profundity toward larger social and political catastrophes.

The lives of these women were brutally cut short, and Hammond exhorts us to register their tragedies. Hammond's desire to "complete something they can't" takes the

4. This triptych originally featured Richard Avedon's photographic portrait of Marilyn Monroe to the right of Rita's self-portrait. The editors of *A Due Voci* contacted and appealed to Mr. Avedon repeatedly, requesting that he let us include his portrait of Marilyn. Through his representatives, Mr. Avedon refused. I offer here not a replacement for the image Rita wished to include in her triptych but a representation that, I believe, suggests some of the pathos of Avedon's portrait; the image is a still from Monroe's final completed movie, *The Misfits* (1961). Avedon's image is primarily a head shot, in which Monroe appears lost. Her bewildered look runs counter to the photographer's highly sexualized presentation of her (wet lips, sequined dress). While the photograph included here may be formally quite different, offering in the presence of the tree much more context than does the Avedon, the image shares its sense of melancholy. In both images Monroe looks askance, and in both she appears trapped and forlorn in that condition. Monroe is such an extraordinary cultural icon that almost any image evokes a range of emotions, a reality Avedon's portrait is clearly aware of. It is thus interesting that after Avedon refused to let us include his image in *A Due Voci*, I found very few images that even came close to documenting the grief that characterizes some of the emotions Monroe's story awakens in us. Mostly what is on offer are glam shots.

form, here, of adding something to our consideration of Frank and Monroe as we see Hammond gazing directly at the viewer. While Frank and Monroe look to the side, Hammond's gaze confronts us, urging us to think about the object status of Frank and Monroe.[5] The Dutch victim of the Holocaust and the shattered by-product of the Hollywood dream factory are in some sense given agency by Hammond's mediation. Frank and Monroe now actively *reflect* their object status as women captured by the gaze of the camera. The capture resonates because we share the knowledge that whenever we look at these familiar portraits, the context of exploitation or cruelty—and of course, utter inhumanity in the one case—is evoked, as both Frank and Monroe were erased completely by blind hatred in the one case and institutionalized desire in the other. Aggressively placed as it is smack in the middle of historical trauma, Hammond's unheroic face is compelling.

In the fall of 1997, Hammond told me about an essay in *The New Yorker* she said I "must" read. The article, written by Cynthia Ozick, is about the appropriation of Anne Frank by popular commentary that has had the effect of turning Frank into a "merry innocent and steadfast idealist" (Ozick 1997, 82). I recently reread the essay, thinking about Ozick's argument in relation to Hammond's triptych and then, too, thinking about the impact that Ozick's essay clearly had on Hammond herself. Ozick's essay bears significantly on Hammond's work. For Ozick, popular culture has transformed a little girl brutalized by the Holocaust into an ahistoric icon symbolizing the indefatigability of the human spirit. Ozick thus has trouble with the "usurpation" of the particulars of individual experience by clichéd claims of universality, asserting that "Anne Frank's story, truthfully told, is unredeemed and unredeemable" (78).

While the title of Hammond's piece, *They Would Be My Age Now,* is one of those gestures that most seems to lend itself to a reading of Hammond's work as pastiche, introducing a set of images only as a means of sparking recognition in the observer, I believe that Hammond's work is very much in line with Ozick's critique. This, in fact, may explain Hammond's preoccupation with the article. Hammond's triptych utterly resists sentimentality; there is nothing "shallowly upbeat," in Ozick's words (1997, 80), about Hammond's placement of a photographic self-portrait between familiar or famous images of Frank and Monroe. Two central insights emerge from examination of Hammond's triptych: first, that Hammond's direct gaze at the spectator—pointed-

5. The gesture is reminiscent of T. J. Clark's analysis of why Manet's "Olympia's Choice" was so controversial: unlike the classic nude (of Titian, for example) who looks dreamily toward heaven, allowing the viewer to voyeuristically possess her through the eroticized mastery of the gaze, Manet's courtesan looks straight at the viewer, as if to say, you made me who I am, so here I am—the price of your fantasy is not only that you're going to have to look me in the eye as you imagine mastering your object of vision, but also that you will be forced to acknowledge your complicity in the culture's commodification of desire (see Clark 1984, 79–146).

ly in contrast with the off-camera "looks" of Anne and Marilyn, as I have suggested above—functions as a critique of the very objectification of these women that Ozick finds troubling in the case of Anne Frank; second, and this is a related point, Hammond's image—so clearly the face of an unadorned old woman—refuses to gloss over the terms of her own survival, thus completing a critique of the transformation of these other women into icons.

There is, of course, only limited parity among the lives of these women, who have and are contained by separate histories. As much as we like to imagine that women occupy similar positions in culture and history, and as much as we may want to sentimentalize the shared fate of these three women, I don't think Hammond meant to elide the differences among the lives and experiences of the women pictured in *They Would Be My Age Now.* Indeed, those of us (including Hammond) who reflect on these images meet each portrait discretely, considering the separate forces and institutions that eviscerated the women beside Hammond. Further, we make judgments about the distinct histories that surround these women, one of which was remarkably worse than the others. Hammond's wizened appearance between Frank and Monroe registers not an idealized heroism or a healing postscript to these women's stories, but the mere fact that she survived into her seventies and these other two women did not.

Hammond's triptych thus works against the spirit of pastiche (to the extent that we can attribute a "spirit" to pastiche). The piece is not an evasion of history, but a direct confrontation with the tragic historical fact of Anne Frank and Marilyn Monroe not living to be old women. Of course, for those who knew Hammond and her spirited grasp of life's possibilities, her death—the limits of her own ability to transcend mortality—is poignantly embedded in her stare into the camera.

Fascination with the Hollywood star system didn't stop with Hammond, or with Monroe. Even Anne Frank dreamt of going to Hollywood. By the age of ten, Frank was seduced by the lure of Hollywood and "the look" of the Hollywood female star. As a definitive version of her diary shows, Frank annotated a great many portraits of herself. One such annotation of an image very similar to the one Hammond includes in *They Would Be My Age Now* is as follows: "This is a photograph of me as I wish I looked all the time. Then I might still have a chance of getting to Holywood [*sic*]. But at present, I'm afraid, I usually look quite different" (Frank [Oct. 10, 1942] 1989, 282). Frank's concern for appearance, which is itself in some way produced by the pressures of the Hollywood star system, extends to the specific image in *They Would Be My Age Now.* This image was one in a series of passport photos. Next to the two images above this photograph, Frank wrote (respectively), "pity about the ugly teeth" and "obviously a flop." The annotation to the image Rita chose is "nice" (293).

Like Marilyn Monroe, Louise Brooks was objectified by American celebrity wor-

ship. Having escaped Hollywood at an early age, however, Brooks was more success-ful than Monroe at negotiating its negative political machinery. Hammond's androgy-nous response to Brooks marks that success. Rendering Louise Brooks as a male-drag version of "Lulu" (the character Brooks played in Pabst's silent film *Pandora's Box*, a movie Hammond owned and loved), Hammond elaborates on her fascination with female public images. Another icon of the twentieth century, Brooks's Lulu is a vamp, a femme fatale of the first order. Hammond was interested in exploring what it means for a woman to be seen and to be paradoxically both empowered and disem-powered by the act of being seen. "The vamp," said Hammond, "is always partly a victim" (1999). By capturing herself as an object of vision that inverts the ideal of feminine beauty (masculine and aged), Hammond reveals the complex position of a woman perceived to be in control who is also on display.

As Lulu, Louise Brooks functions as a projection of cultural desires and anxieties. Brooks, like Marilyn Monroe, felt the extraordinary burden of having been trans-formed into an image, "derealized," as Mary Ann Doane has put it, in relation to Brooks (1991, 146). The oft-quoted comment of Henri Langlois is telling in this regard: "like the statues of antiquity, [Lulu] is outside of time . . . She is the intelli-gence of the cinematographic process, she is the most perfect incarnation of pho-togénie" (Doane 1991, 153). Langlois's formulation is striking in its explicit erasure of a woman in the service of perpetuating a mythic ideal of femininity, "outside of time." Langlois points to our belief on some level that, through technology, photog-raphy and cinema can realize this ideal, ironically, we find, at the cost of *de*realizing the actual woman being photographed or filmed. Brooks herself had a prescient awareness of Hollywood's complicity in constructing an image culture when, much later, at age sixty-nine, she said about leaving Hollywood in 1927, "Nobody can understand why I hated that terrible destructive place which seemed a marvelous par-adise to all others . . . To me it was like a terrible dream I have—I am lost in the corri-dors of a big hotel and I cannot find my room. People walk past me as if they can not see or hear me. So I first ran away from Hollywood and I have been running away ever since" (Jaccard 1986, 144). Hammond's project seems in some sense to elicit this kind of commentary on the transformation of woman into image. In *Pandora's Box*, Lulu eventually meets a brutal end, when she is killed by Jack the Ripper. Brooks reports a conversation she had with Pabst at the end of working with the director: "'Your life is exactly like Lulu's,' he said, 'and you will end the same way.' At that time, knowing so little of what he meant by 'Lulu,' I just sat sullenly glaring at him, trying not to listen. Fifteen years later, in Hollywood, with all his predictions closing in on me, I heard his words again—hissing back to me" (Elsaesser 1983, 34).

The poignance of Brooks's commentary lies in part in the intelligence of her artic-

ulation of what happens to women stars in Hollywood, "[becoming] an object among objects, alive only in front of the camera" (Elsaesser 1983, 34). Hammond wants to lend Louise Brooks a subject status, some agency, so that, in the words of Amelie Hastie, "[Brooks] *looks* rather than is simply *looked at*" (1997, 5). Indeed, Hammond plays Louise Brooks as *looking*, and the face that actively looks is androgynous, mirroring the "fundamental aspect of [Lulu's] mutability, her free-spiritedness, the transgression of conventional boundaries—all of which constitute her eroticism, her desirability" (Doane 1991, 153). While the collapse of these boundaries may constitute Brooks's power as image of female sexuality, it does so in a way strongly worth considering, since it is these binary oppositions that objectify women as feminine (vs. masculine), as heterosexual (vs. lesbian), as passive (vs. active), as object (vs. subject), as image (vs. real woman). Hammond's playful response to Lulu also functions to endorse a more flexible, less static—ultimately a more performative—image of woman, empowering her to take on whatever role she, as agent of her own desires, chooses.

Just as the triptych *They Would Be My Age Now* relies heavily on context, on our knowledge of the stories and history behind the images of Frank and Monroe, these "due voci" gain much complexity and force by our knowledge of the vamp behind the doe-eyed ingénue glance of Lulu and of Hammond's age and sex, belied by her male-drag look and "black helmet" (Tynan 1979). It is no coincidence that Hammond shows particular interest in female tragic figures, a subject familiarly aestheticized, from the Virgin Mary to Joan of Arc, to Ophelia and to Pre-Raphaelite fallen women. Anne Frank, Marilyn Monroe, and Louise Brooks—all strong women whose images came to be owned by the public at large, in different contexts and to different ends—attempted to escape victimization through the production of illusion.

What drew Hammond to women like Frank, Monroe, and Brooks was her admiration for their struggles. Even though these women didn't succeed in their resistance, they showed tremendous strength in defying enormous psychological and social pressures, and in the case of Brooks and Monroe, the phenomenal burden of becoming cultural icons. It may be the case that Monroe's suicide expressed this rebellion against being used as a tool for society to negotiate its attitudes towards sexuality.[6] Certainly Monroe herself recognized her function as a projection of cultural anxieties and desires when she said, "I'm always running into people's unconscious" (MacCannell 1987, 126). This surprising insight may help to illuminate the bizarre and overdetermined comment of Tony Curtis, her co-star in *Some Like It Hot*, who famously said that "Kissing Marilyn Monroe was like kissing Hitler" (MacCannell 1987, 124).

6. See Richard Dyer's (1988) excellent essay on Monroe's relation to 1950s conceptions of sexuality in "Monroe and Sexuality."

Marilyn Monroe and Louise Brooks resisted, but of course it's very difficult to defy an ideal, the myth of female perfection. Hammond shows the value of marking that resistance by unapologetically presenting her own imperfection. Her stark presentation of her age, as well as her weathered appearance, reveals these varied institutionalizations of "derealization," suggesting the tragic personal and cultural costs of the process.

What connects these pieces I've discussed—the Bayard, the Frank / Hammond / Monroe triptych, and Lulu—with other images in the book that may seem more whimsical is the question of what we, as viewers of art and as readers of historical loss, are willing to accept. Magritte's "condition humaine" may seduce us through its trompe l'oeils (as Hammond [1999] said, "When you come up against a curb that isn't really there . . . a step that's a little lower, you really get a jarring"), but the image, in conjunction with Hammond's photographic response, and in juxtaposition to the other pieces in *A Due Voci*, has a larger resonance. Hammond isn't only talking about trompe l'oeils, the ways images play with our perceptions, and she isn't trying to fool anyone. In her combined efforts to play with conventional forms of representation and to register the personal and public losses of history, she is recognizing the psychological demands of life, and of living: "what we accept is a tremendous amount" (Hammond 1999).

Because Hammond's work is so much about what we're willing to accept—in life, in art—she continually pushes us to move beyond the conventions we idealize or transform into iconography (the loner artist, the inaccessibility of "high" art). Hammond wishes to remind us of how images *and* individuals survive, and also, how images survive and individuals do not. It would be, for Hammond, a saving grace that images survive, as she repeatedly claims that it is through illusions that we negotiate trauma. Playing with fatalistic realities, Hammond's work is concerned with marking permanence while past and present, youth and age, and life and death simply happen.

This is why Hammond's response to Chardin resonates in the context of *A Due Voci*. Is Hammond competing with Chardin: Who can blow the biggest bubble? Who can make life last the longest? In such a seemingly cheerful body of work, why the preoccupation with skeletons (Munch's "Self-Portrait with Skeleton Arm," Warhol's "Self-Portrait with Skull," Géricault's "Portrait of a Young Man")? As we comment on Hammond's work in the context of her illness and death, these gestures take on a good deal of poignancy. Of course, Hammond didn't know she was sick when she made, or "did," any of the pieces in *A Due Voci*. But it is the presence of both vitality and mortality in Hammond's work that constitutes its deep romanticism, at the same time as Hammond has given us a way of understanding romanticism in a contempo-

rary context that is not escapist, or solipsistic, or superficial, that is not pastiche at all. Hammond's love of art history and illusion—its powers and its limits—imbue every image in *A Due Voci*.

Finally, in an effort to conclude what it means for Hammond to become an image, I want to explore further Hammond's investment in the idea of the photograph. Photography gives Hammond a means of marking moments in history while her play with the images she invades reminds us of their status and function as illusion. In his intriguing book *Camera Lucida* (1981), Roland Barthes explores the meaning of the photographic image. Barthes articulates many of the contemporary anxieties concerning photography's relation to real history and illusion, prefiguring Hammond's poignant use of the image to engage both. Barthes defends photographic realism; his reverence for photography lies not in its status as art per se, but in what he calls the "that-has-been" quality of the image. For Barthes, because the photograph registers an incontrovertible authentication of the thing it records, "the photograph is literally an emanation of the referent" (1981, 80).

Because Barthes's discussion is largely motivated by his attempt to come to terms with his mother's death, his analysis may seem more personal than polemical. And yet, because Barthes rearticulates in pointed and poignant terms a modernist anxiety surrounding the loss of a stable real—because, in other words, he extends the discussion of issues concerning the status of the image raised even in Hippolyte Bayard's time, issues we still grapple with—he does engage in a polemics of cultural loss, which, as I have been suggesting, helps us to situate Hammond's interest in the metaphoric and historic revelations brought about by photography. As Barthes suggests

> To say, confronted with a certain photograph, 'That's *almost* the way she was!' was more distressing than to say, confronted with another, 'That's not the way she was at all.' The *almost*: love's dreadful regime, but also the dream's disappointing status— . . . And confronted with the photograph, as in the dream, it is the same effort, the same Sisyphean labor: to reascend, straining toward the essence, to climb back down without having seen it, and to begin all over again. (66)

This notion of "straining toward" the real and the vague echo of J. Alfred Prufrock's broken connection to those outside of his fragmented sense of self—"That is not what I meant, at all" (Eliot 2000, 2366)—in Barthes's "that's not the way she was

at all" resume the anguished mourning for the real and for an unironic stable source of meaning that is a continued strain in contemporary culture dating from nineteenth-century debates about the role and meaning of the image. Thus Barthes's conclusion is, in a way, a plea, an exhortation to a world of those who appropriate the real and the real facts of history (in the words of Oliver Wendell Holmes, photographers "hunt the cattle . . . for their *skins* and leave the carcasses as of little worth" [Trachtenberg 1980, 81]). Barthes wishes to "[raise] the ethical question: not that the image is immoral, irreligious, or diabolic (as some have declared it, upon the advent of the Photograph)"—and, we might add, as some still do, debates now intensifying about whether representations of violence cause real violence—but whether, "when generalized, it completely de-realizes the human world of conflicts and desires, under cover of illustrating it" (1981, 118). Barthes's polemics conclude with his expression of preference for meaning and pain: "Such are the two ways of the Photograph. The choice is mine: to subject its spectacle to the civilized code of perfect illusions, or to confront in it the wakening of intractable reality" (119).

The point brings us back to Hippolyte Bayard's illusory suicide, the image with which Hammond wanted to begin "A Due Voci." Bayard's performance of death—a performance, perhaps, in preparation for death—not only transforms loss (of opportunity, of fame) into gain (an immortal register of that loss), but also calls attention to the status of the photographed object as present and absent, as there and not there, just as Hammond is palpably there with Brooks, Monroe, and Anne Frank, and palpably not there. Throughout *A Due Voci*, Hammond explores this double nature of the photographic medium, as Bayard did, by "[playing] on the tension between the notion of death and visualization as means of authentication, and the authenticity inherent in the act of making death visible" (Sapir 1994, 620). Sapir continues, "As such [Bayard's self-portrait] can be seen as an early critique of the dominant ocular-centric scopic regime of post-Enlightenment modernity, which assumed a transparent relationship between photography and truth" (620). So, too, Hammond "questions precisely [the] Realistic pretense of the photographic medium to achieve immediacy and truthfulness" (Sapir 1994, 624). Not only is Hammond deeply interested in this paradoxical authenticity and inauthenticity that the photograph instantiates, but her work very much enacts this concept, because in *A Due Voci*, "the author is both present and absent" (623). The idea takes on greater complexity still when we consider Bayard's phantom suicide, erasing himself at the same time as he inscribes himself onto an (art) historical record.

Alluding to Barthes's *Camera Lucida*, Sapir notes that "to question immediacy is closely linked to death" (1994, 628). Hammond's photography calls attention to the presences and absences inherent in the image, in a fashion akin, perhaps, to what

Arthur Miller meant when he said about Marilyn Monroe that "being with her, people want not to die" (MacCannell, 116). The quote works as well for Hammond: the comment captures the tremendous power of the image; for Hammond, of all images. Hammond was committed to drawing forth this power by transforming loss, pain, and consciousness of the brevity of life into the kind of imaginative play that invites audiences to share in a momentary staving off of mortality.

*A Due Voci*

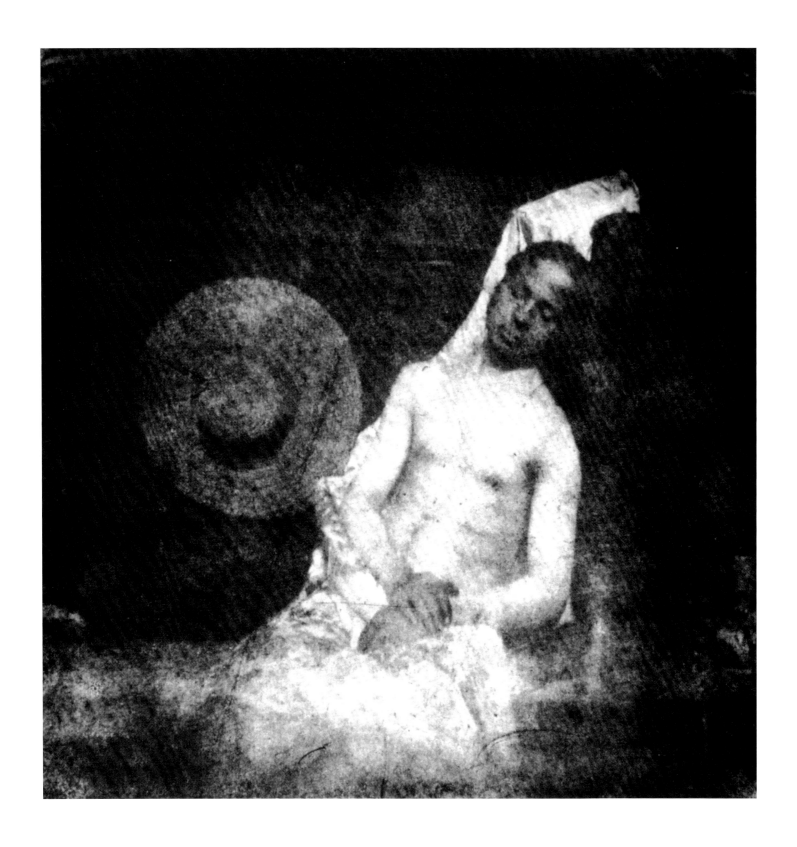

Hammond after Bayard (Collaboration with Lynn Moser)
Hippolyte Bayard, *Self-Portrait as a Drowned Man*, 1840.

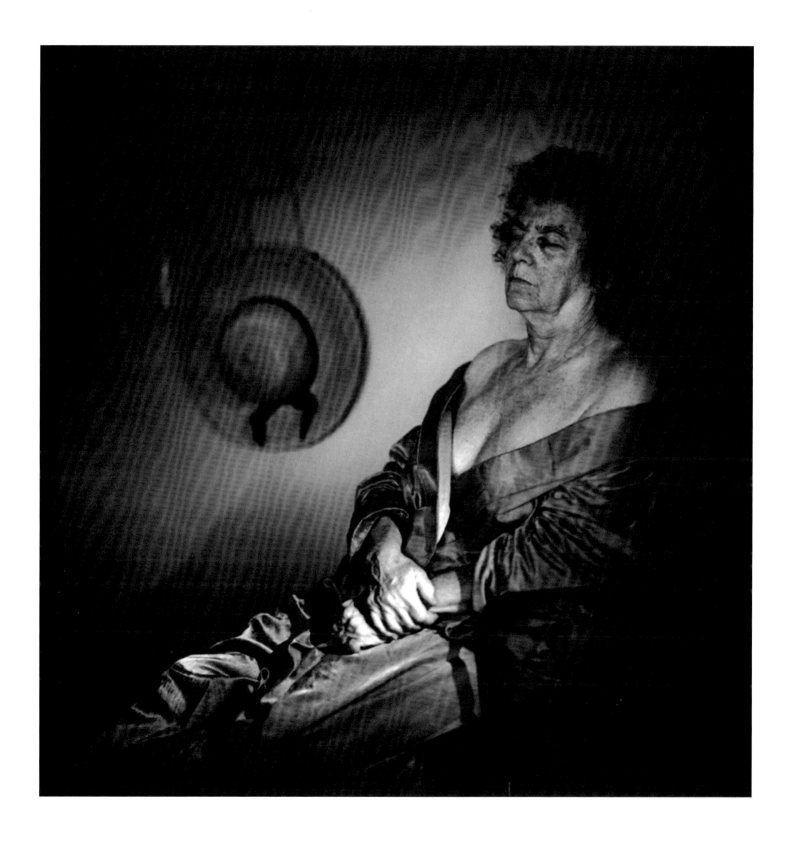

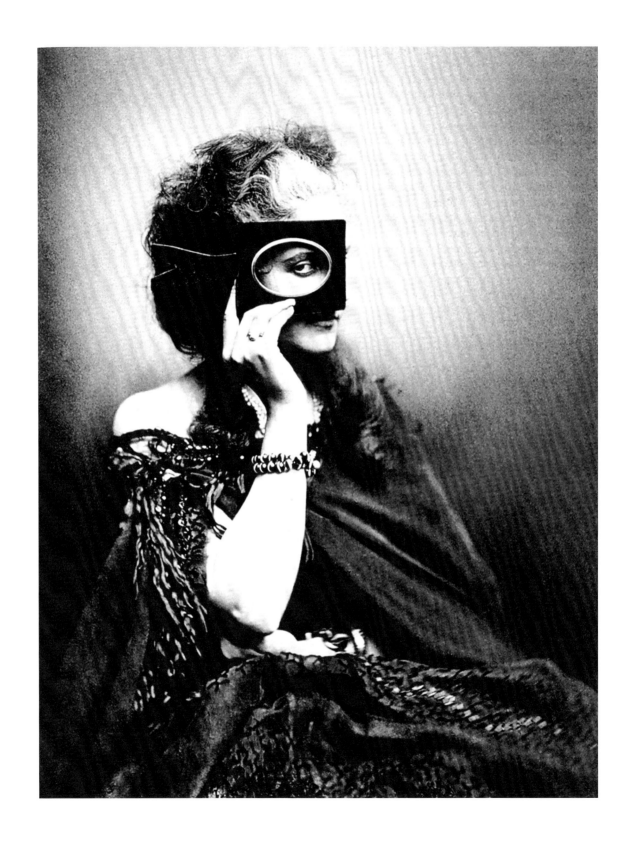

Hammond after Oldoini
Virginia Oldoini (Countess de Castiglione) and Pierre-Louis Pierson, *Scherzo di Follia*, ca. 1861.

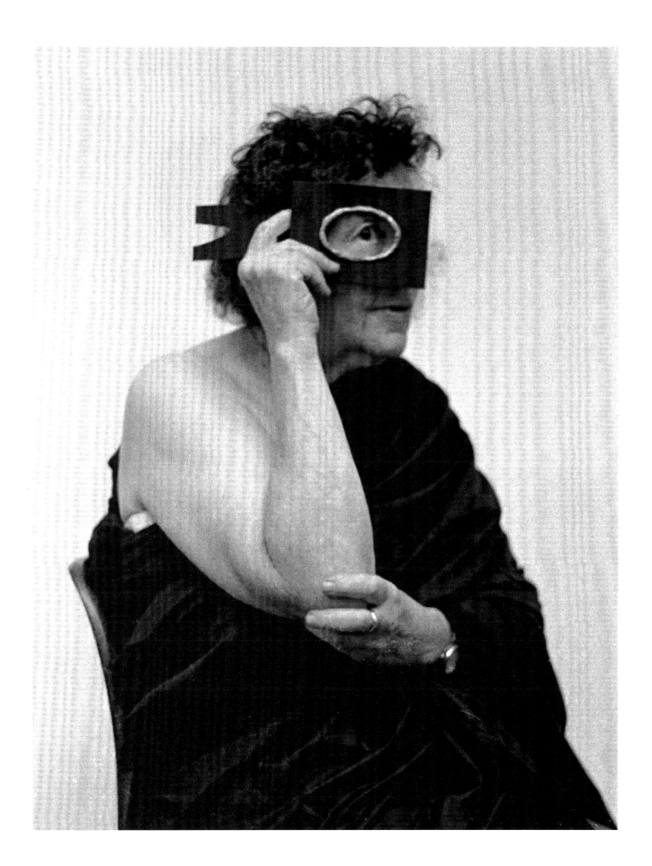

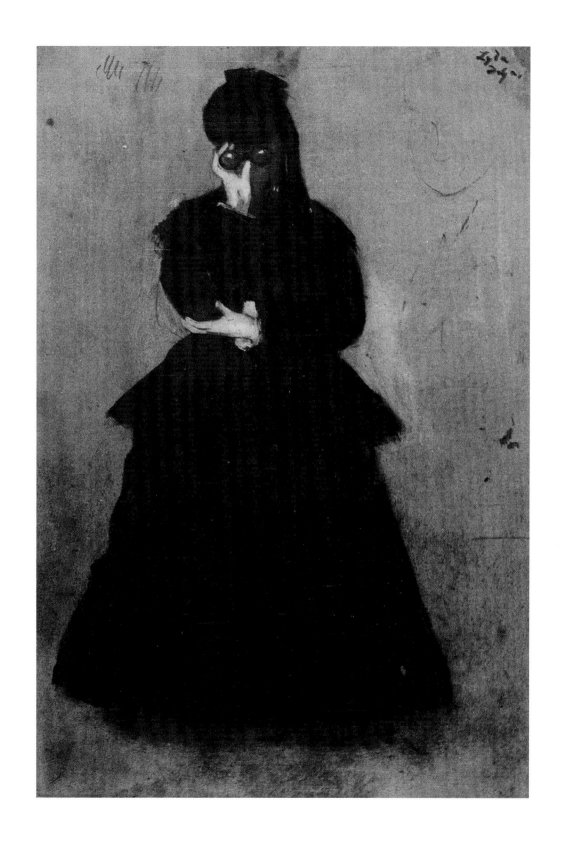

Hammond after Degas

Hilaire-Germaine-Edgar Degas, *Woman with Field Glasses*, ca. 1869.

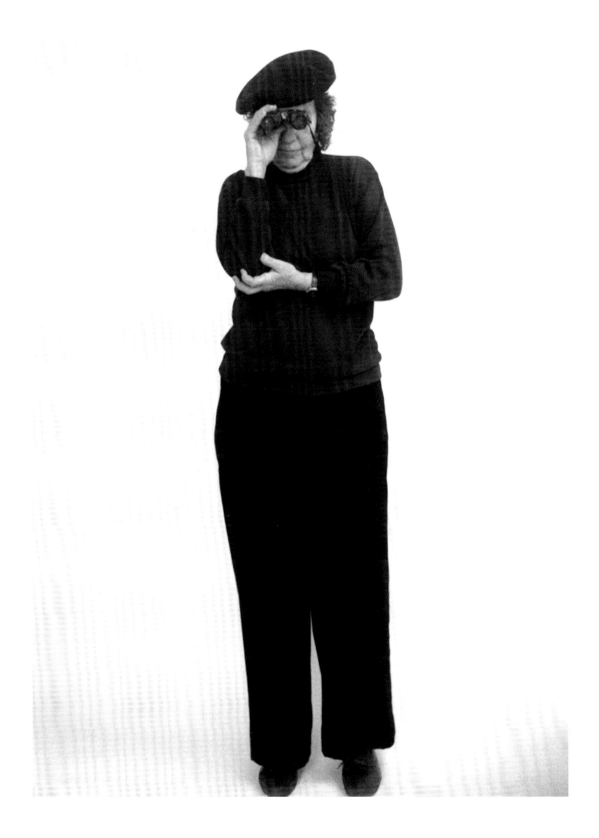

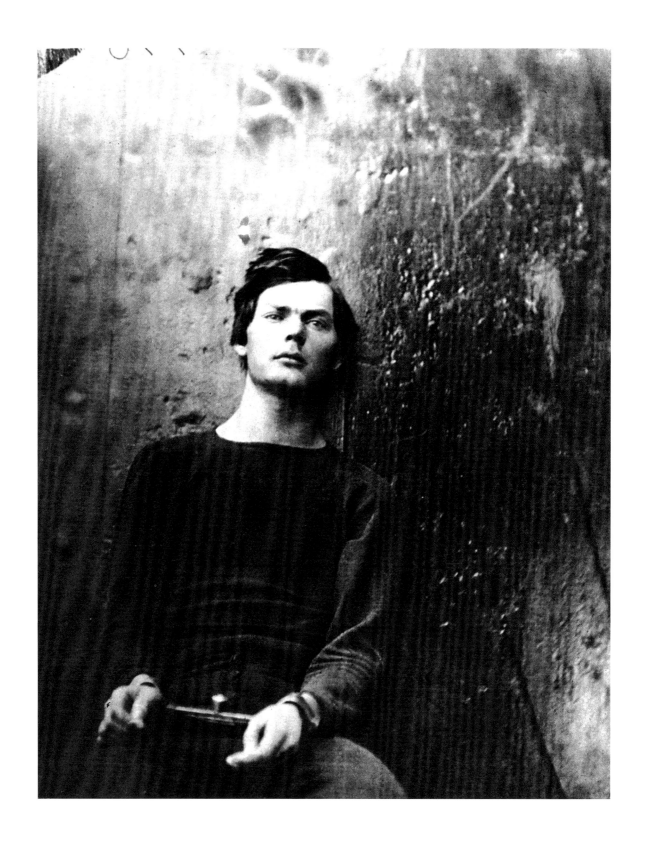

Hammond after Gardner

Alexander Gardner, *Paine on the Saugus*, April 27, 1865.

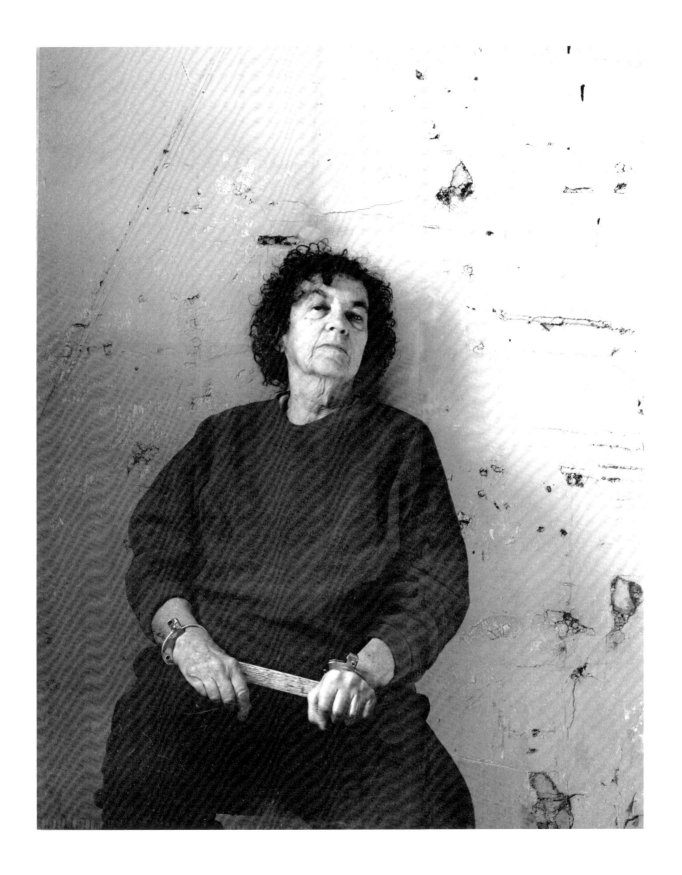

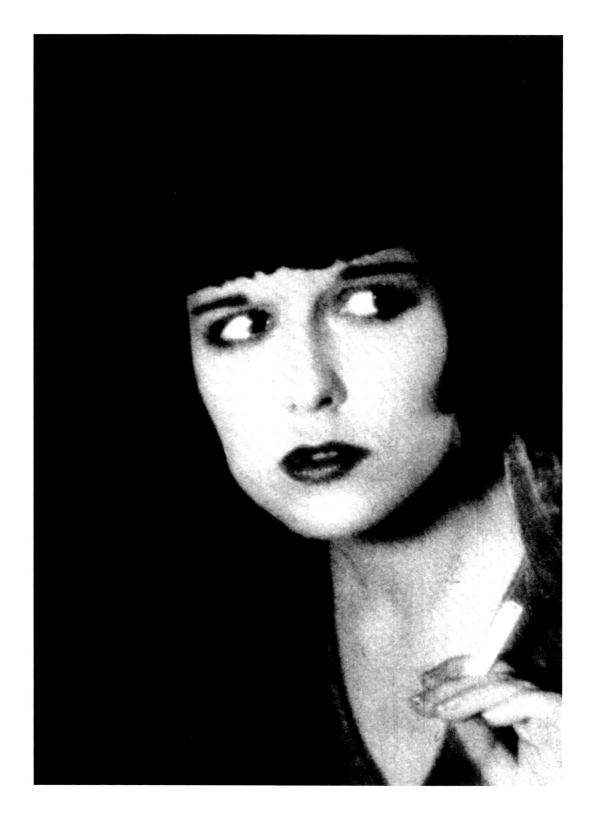

Hammond after Brooks
Louise Brooks, movie still as Lulu, ca. 1929.
Courtesy of Phototheque Cinematheque Suisse. Droits réserves.

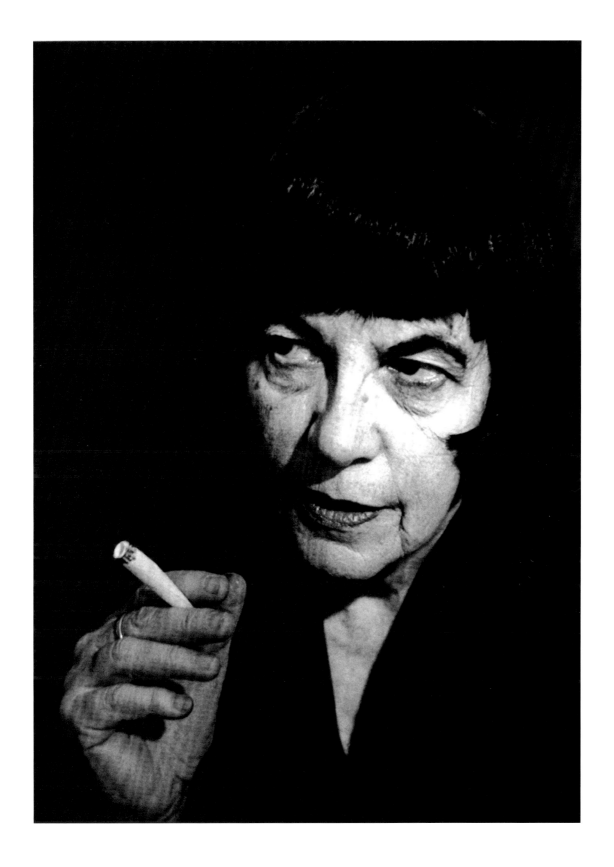

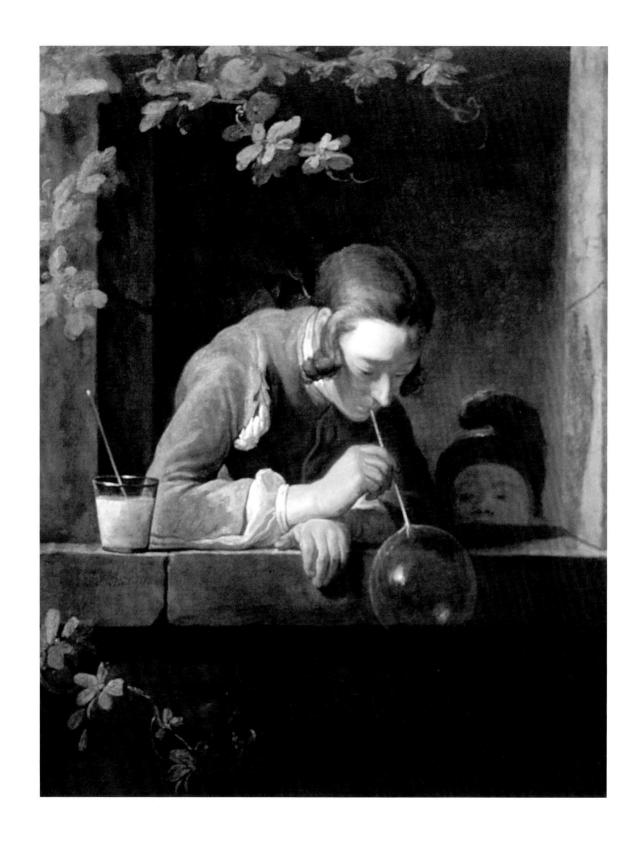

Hammond after Chardin

Jean-Baptiste-Siméon Chardin, *The Soap Bubble*, ca. 1733.

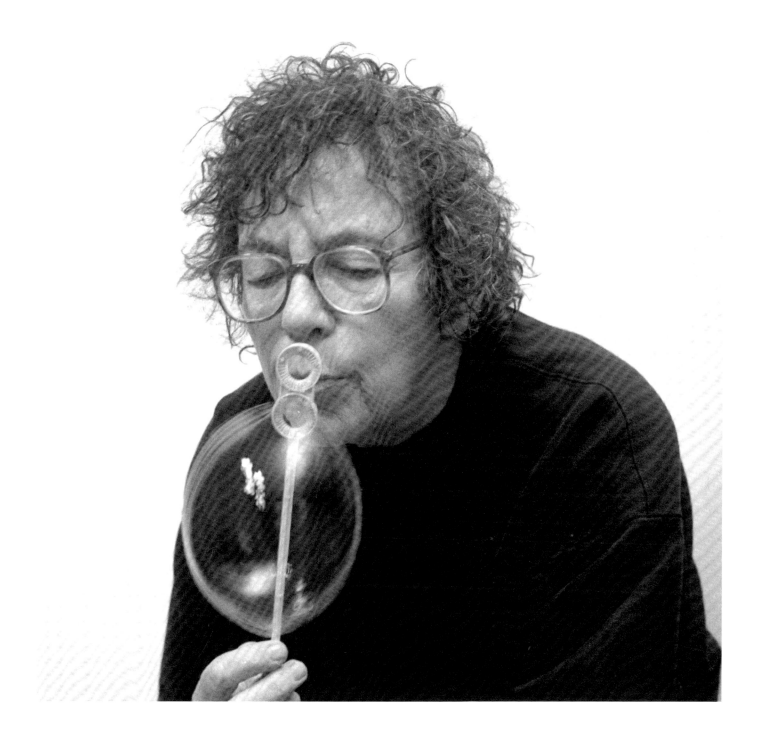

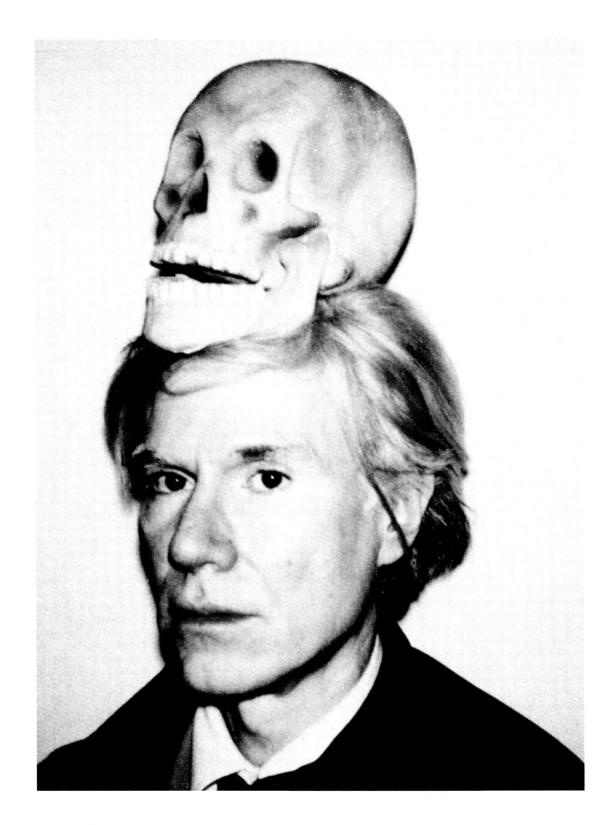

Hammond after Warhol

Andy Warhol, *Self-Portrait with Skull*, 1977. Copyright © 2002 Andy Warhol Foundation for the Visual Arts/Artists Rights Society (ARS), New York. Used with permission.

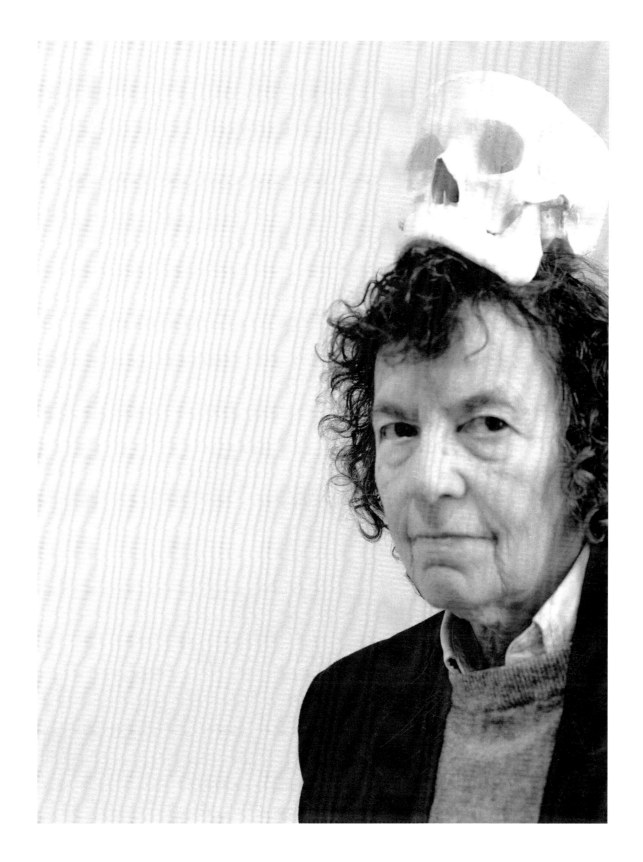

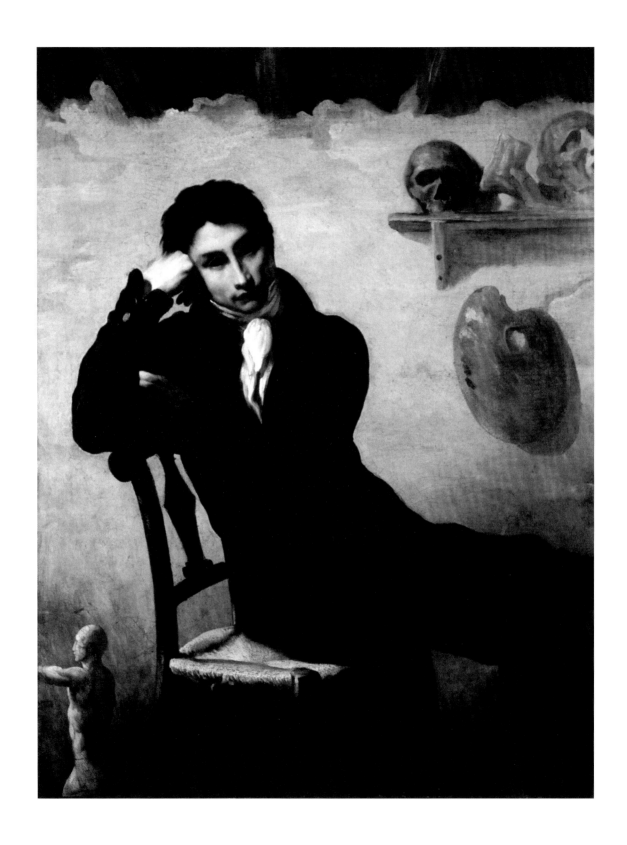

Hammond after Géricault

Jean-Louis-André-Théodore Géricault, *Portrait of a Young Man in an Artist's Studio*, ca. 1820.

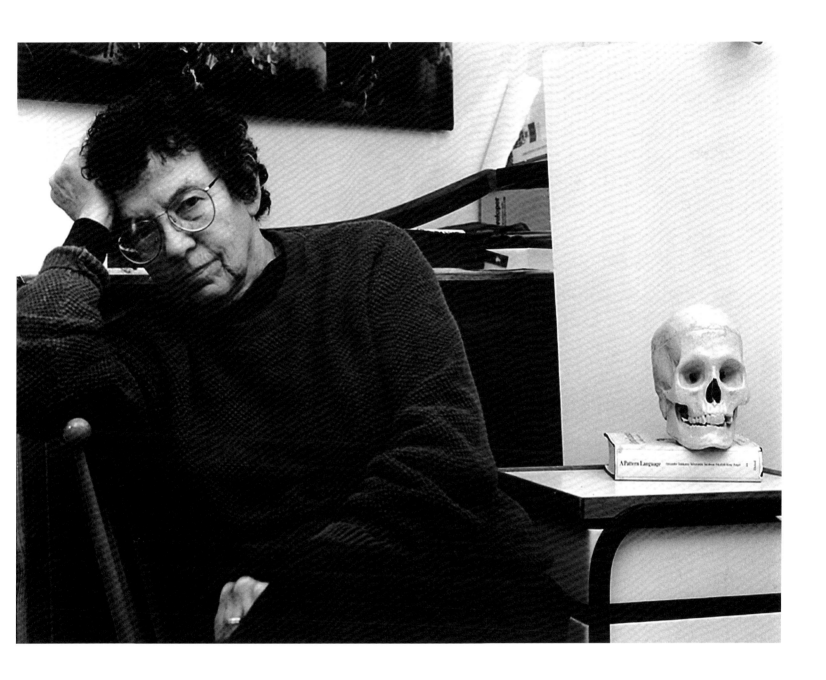

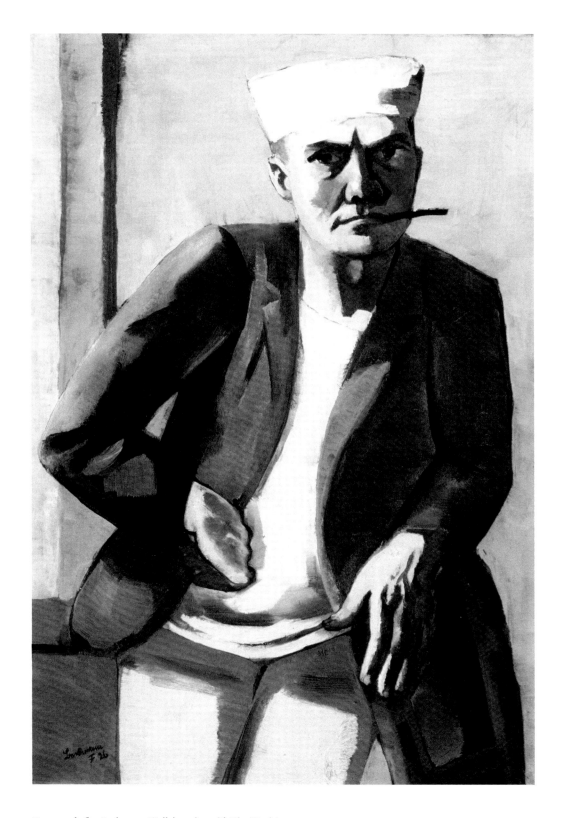

Hammond after Beckmann (Collaboration with Kim Waale)

Max Beckmann, *Self-Portrait in Sailor Hat,* 1926.

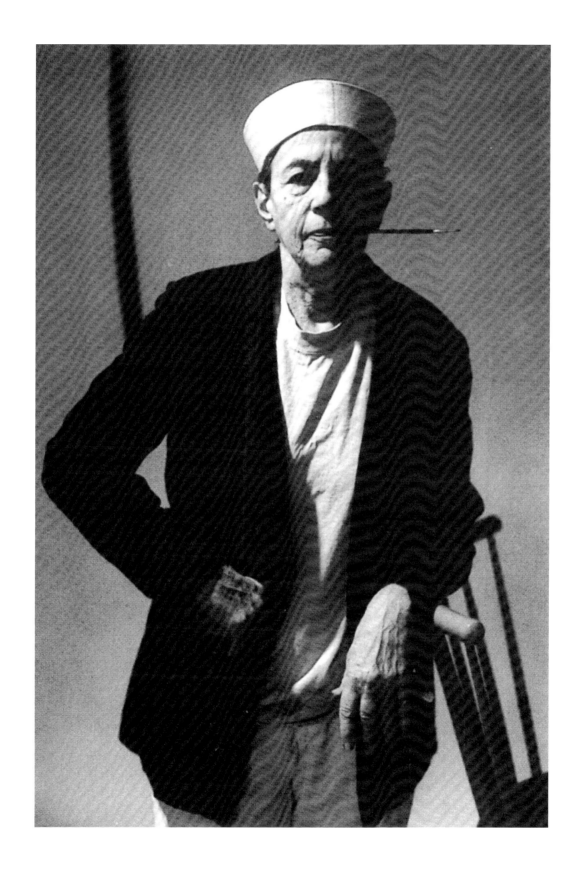

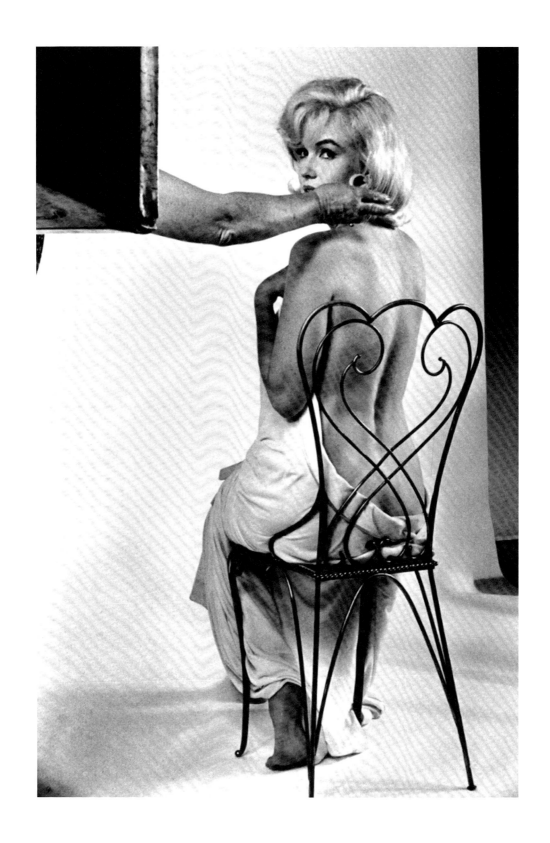

Hammond after Arnold (Photograph by Ray Beale)

Eve Arnold, *Marilyn Monroe (Studio Session)*, 1960. Reproduced with permission by Magnum Photos.

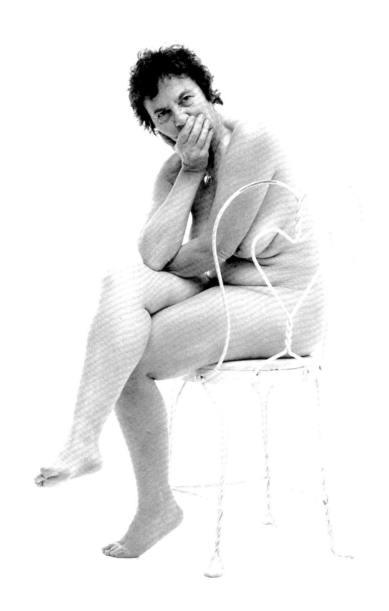

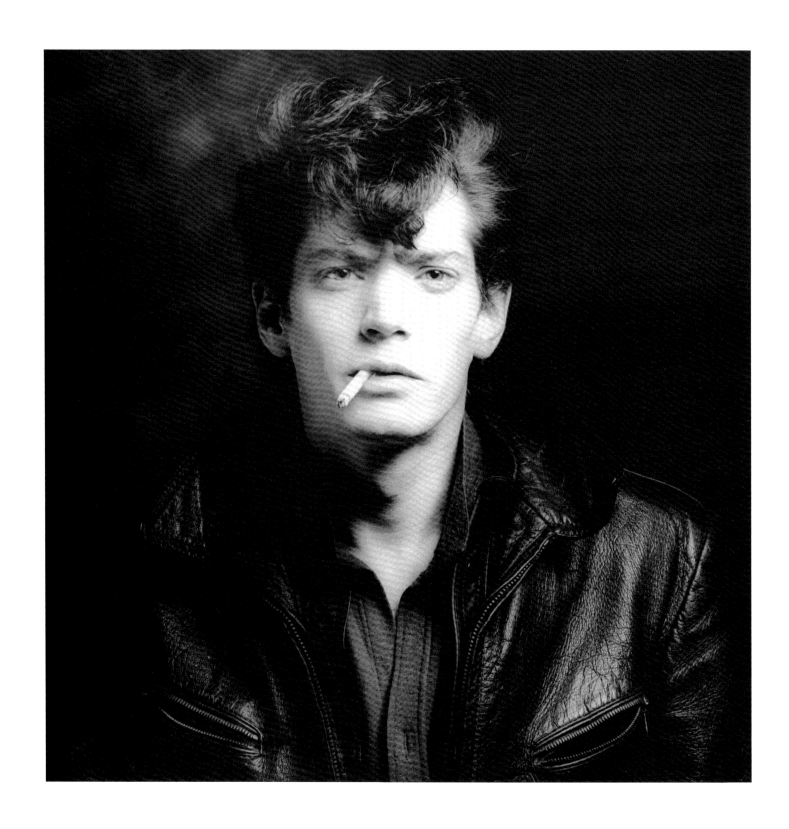

Hammond after Mapplethorpe (Collaboration with Ray Beale)

Robert Mapplethorpe, *Self-Portrait [with cigarette]*, 1980.

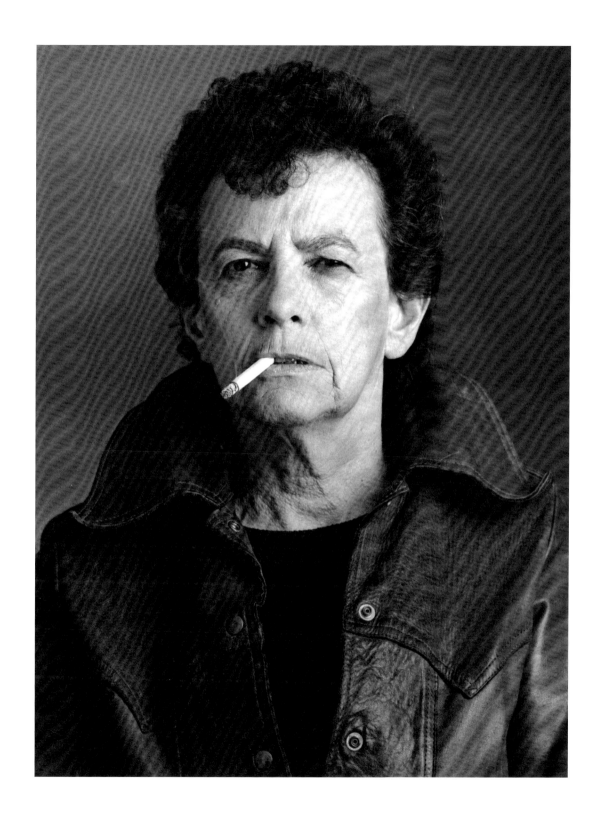

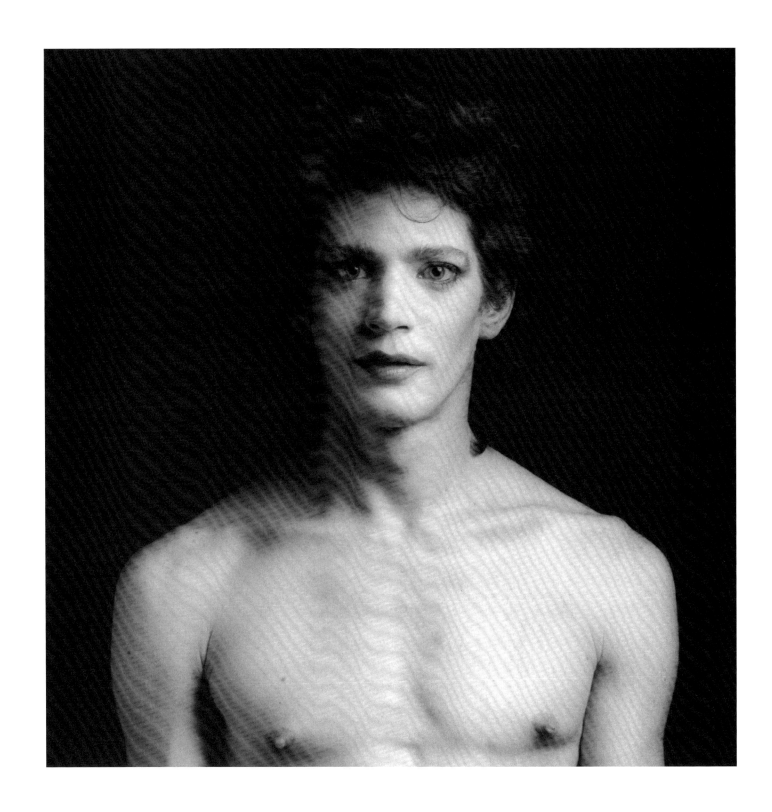

Hammond after Mapplethorpe (Collaboration with Ray Beale)

Robert Mapplethorpe, *Self-Portrait [in drag]*, 1980.

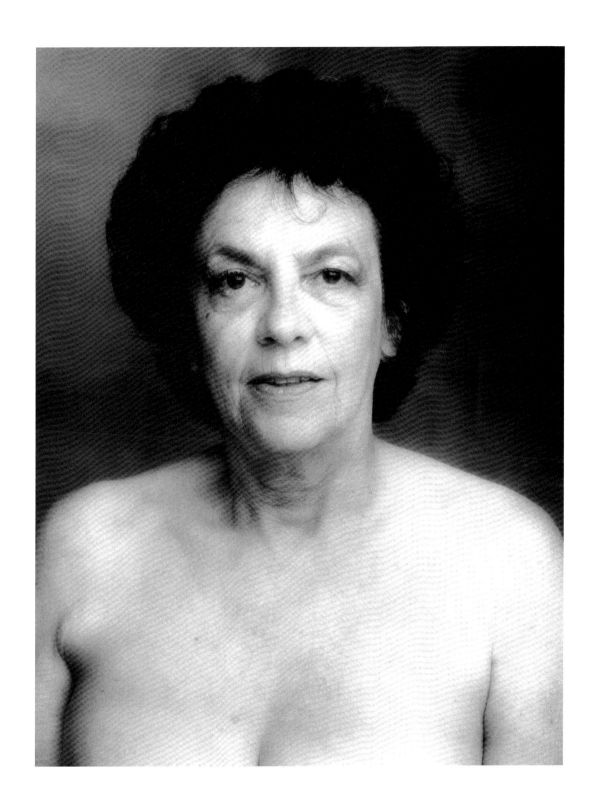

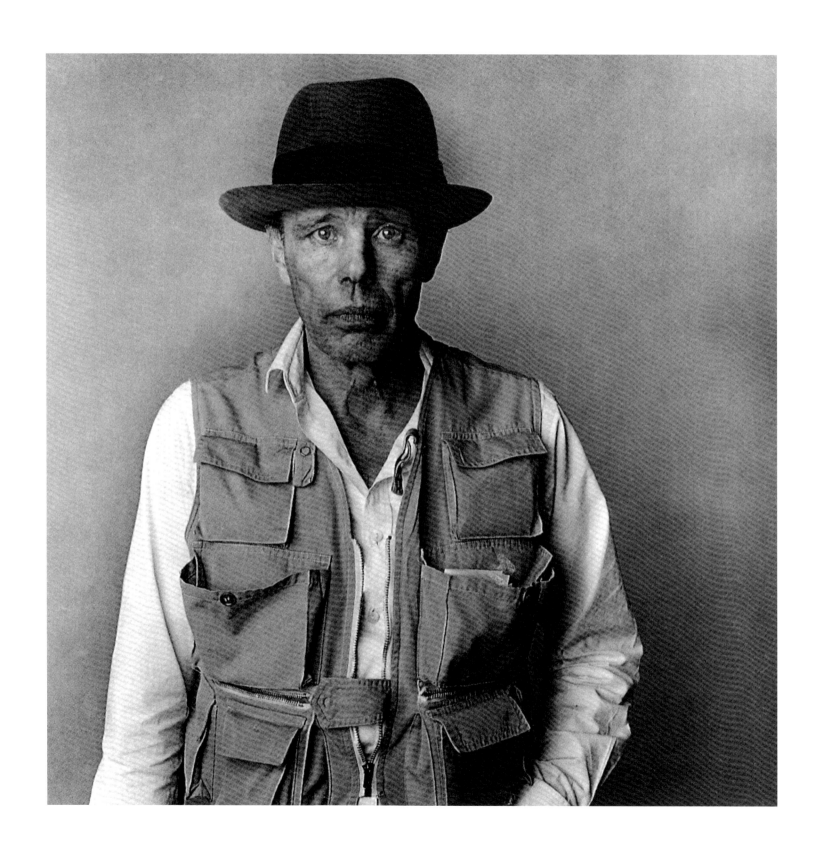

Hammond after Sudre
Laurence Sudre, *Joseph Beuys*.

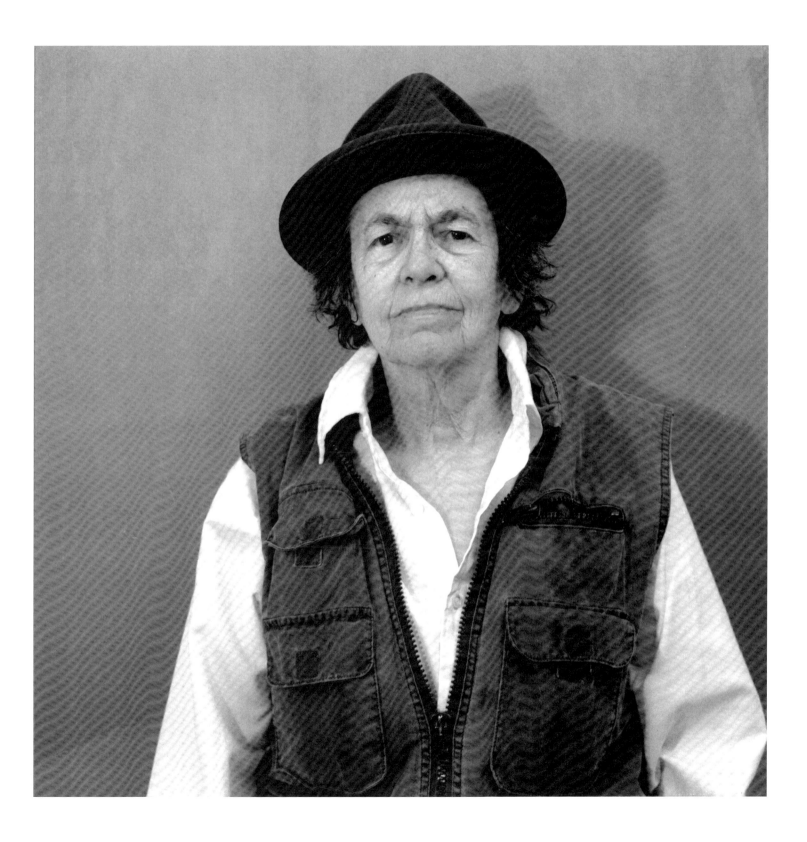

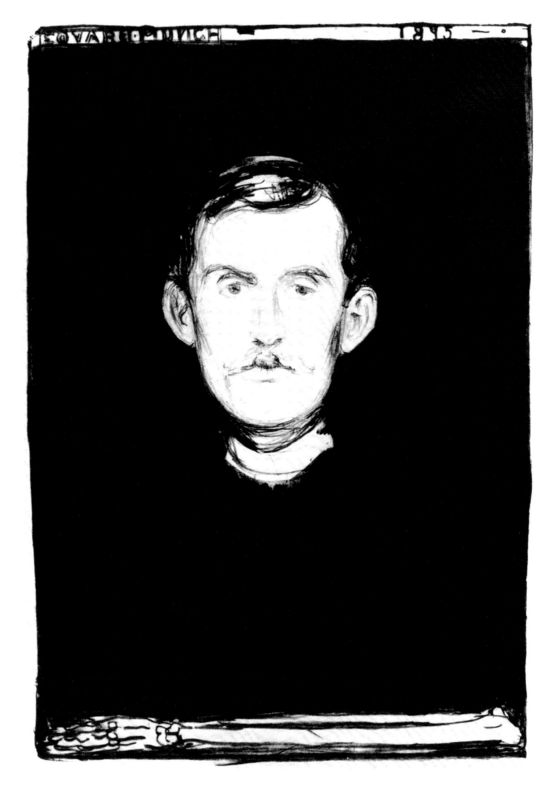

Hammond after Munch

Edvard Munch, *Self-Portrait with Skeleton Arm*, 1895, signed 1896. Lithograph, printed in black, composition: 18⅛ x 12¾ in. (46.1 x 32.4 cm). The Museum of Modern Art, New York. Gift of James L. Goodwin in memory of Philip L. Goodwin. Photograph copright © 2001 The Museum of Modern Art, New York.

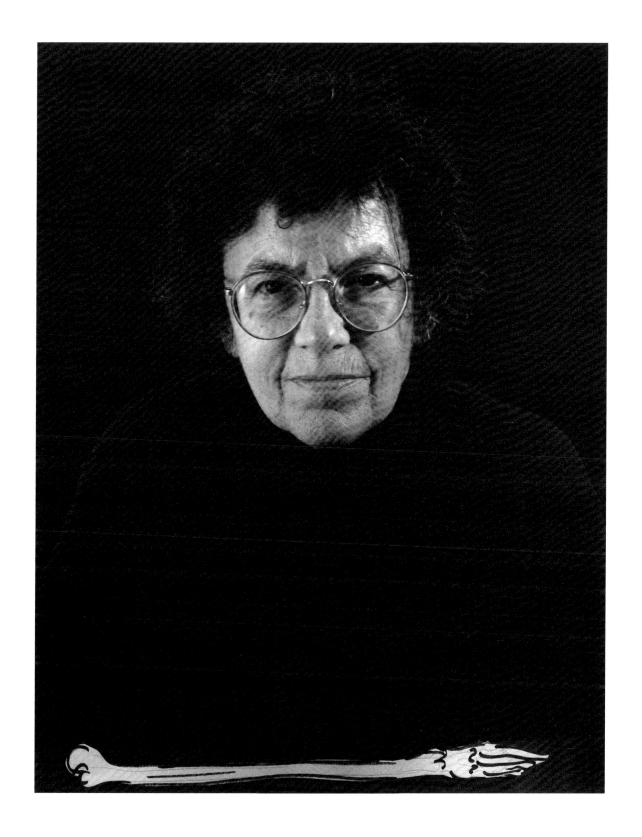

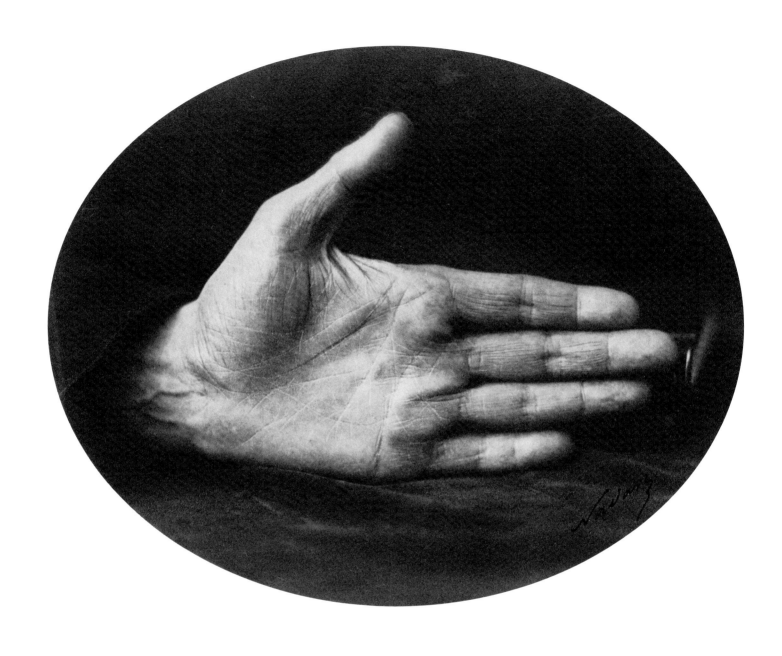

Hammond after Nadar (Collaboration with Lynn Moser)
Nadar (Félix Tournachon), *Banker's Hand*, 1861.

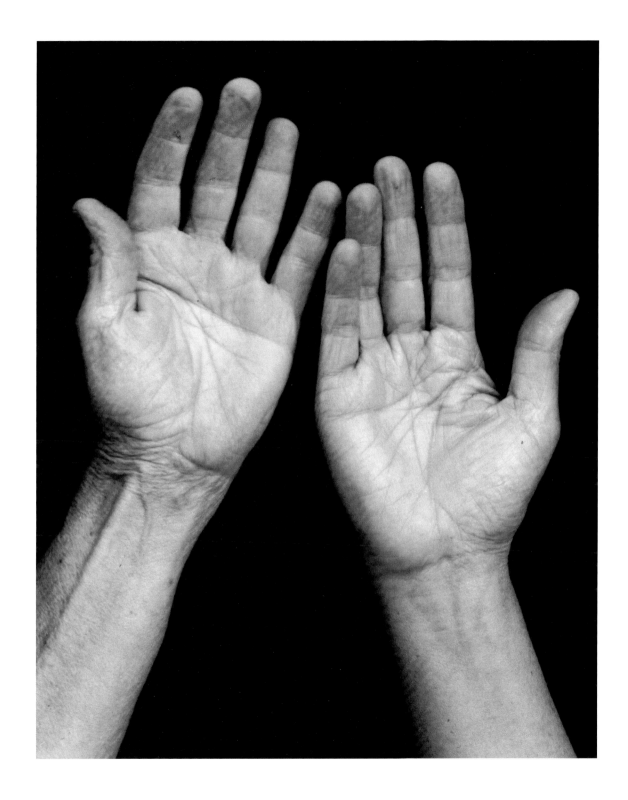

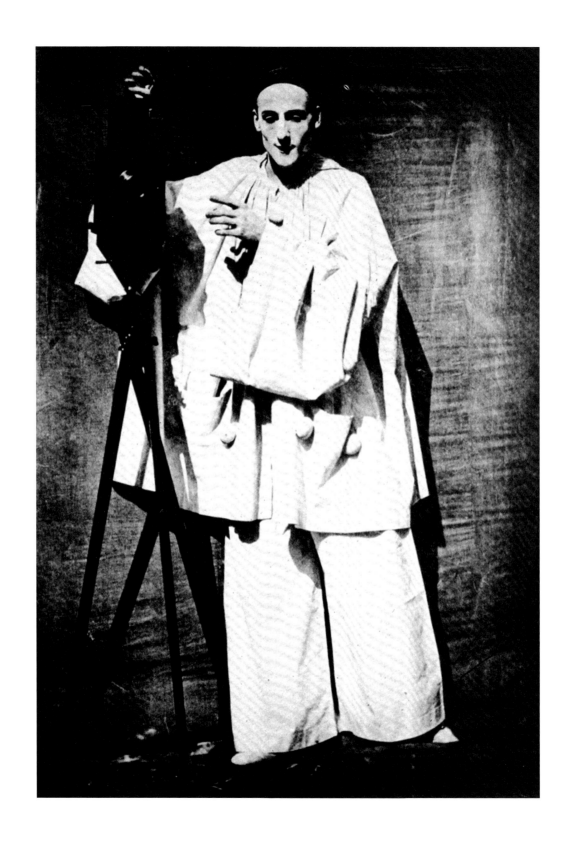

Hammond after Nadar and Tournachon
82  Nadar (Félix Tournachon) and Adrien Tournachon, *Pierrot the Photographer (Charles Deburau as Pierrot)*, 1854–55.

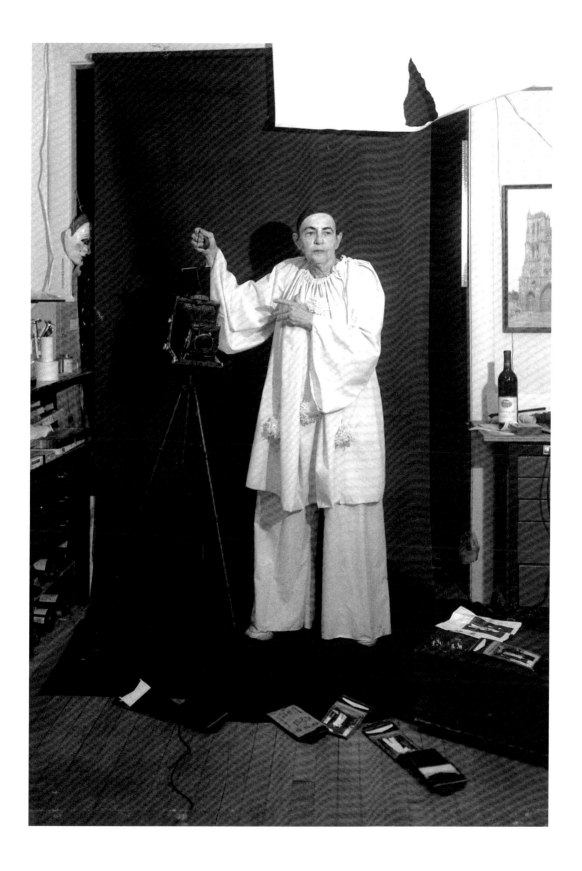

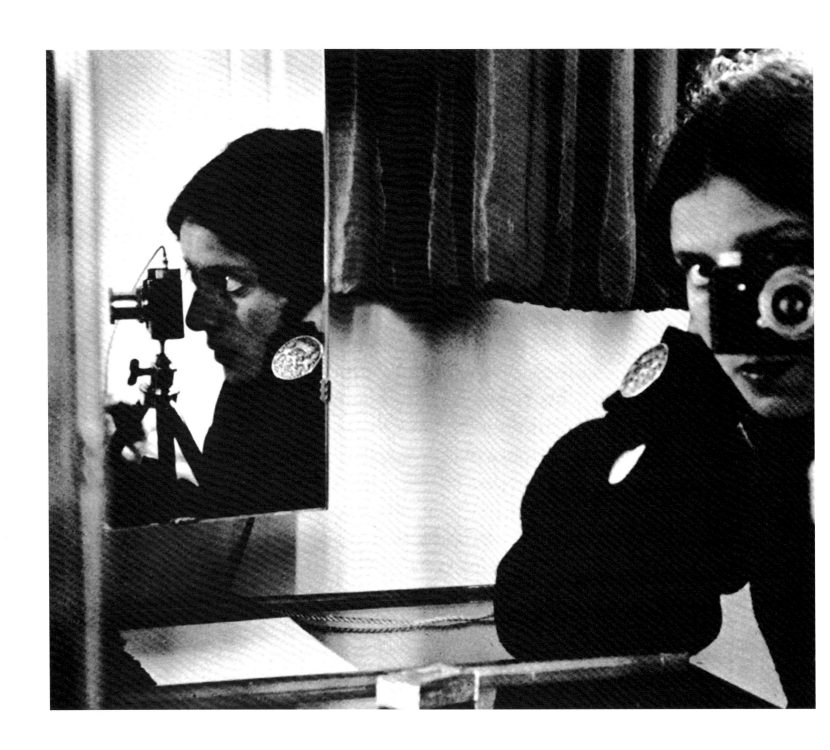

Hammond after Bing
Ilse Bing, *Self-Portrait with Leica*, 1931.
84     Courtesy Edwynn Houk, Advisor, The Estate of Ilse Bing.

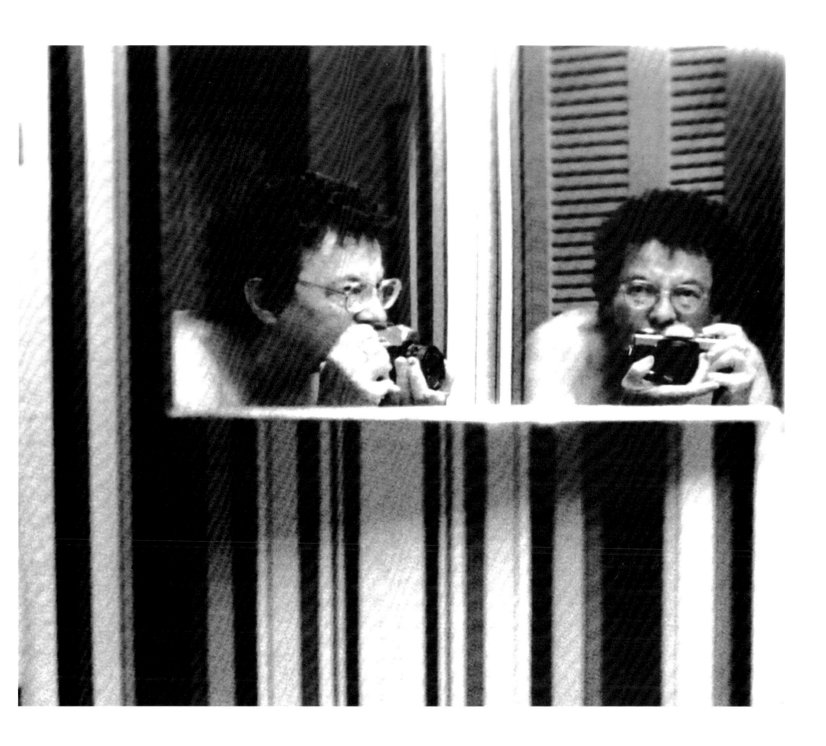

Hammond after Magritte

René Magritte, *The Human Condition* ("*La Condition humaine*"), 1933.

Hammond after Durand (Collaboration with Lynn Moser)
88    Asher Brown Durand, *Kindred Spirits*, 1849.

Hammond after Gauguin

Paul Gauguin, *Meyer de Haan*, 1889.

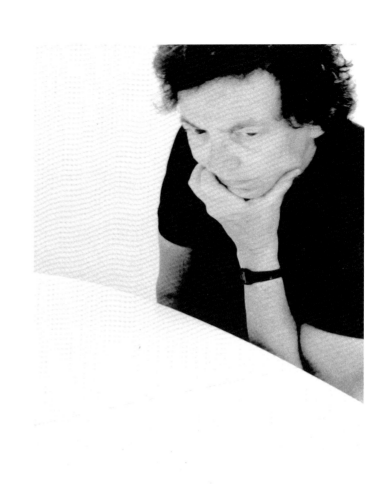

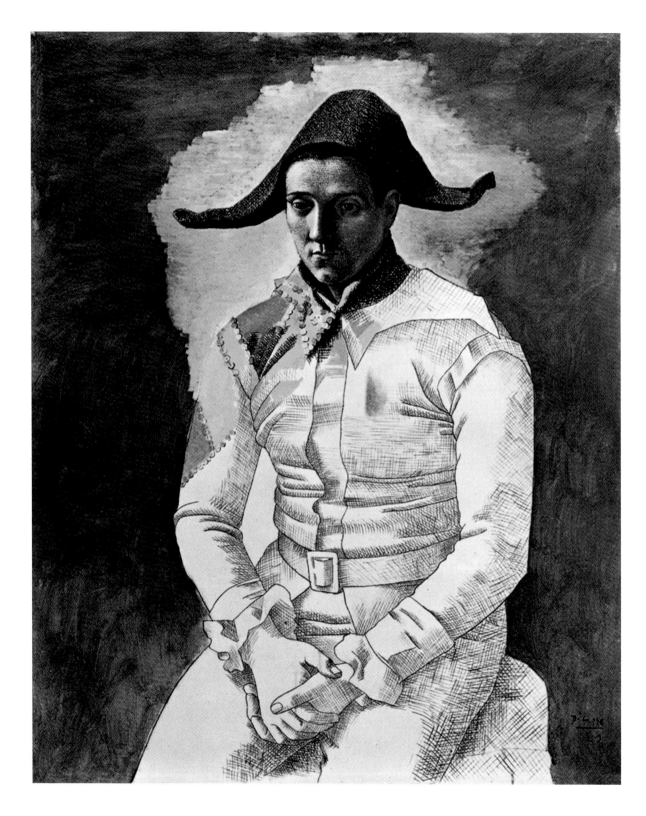

Hammond after Picasso (Collaboration with Kim Waale)

Pablo Picasso, *Seated Harlequin (Portrait of the Painter Jacinto Salvado)*, 1923.

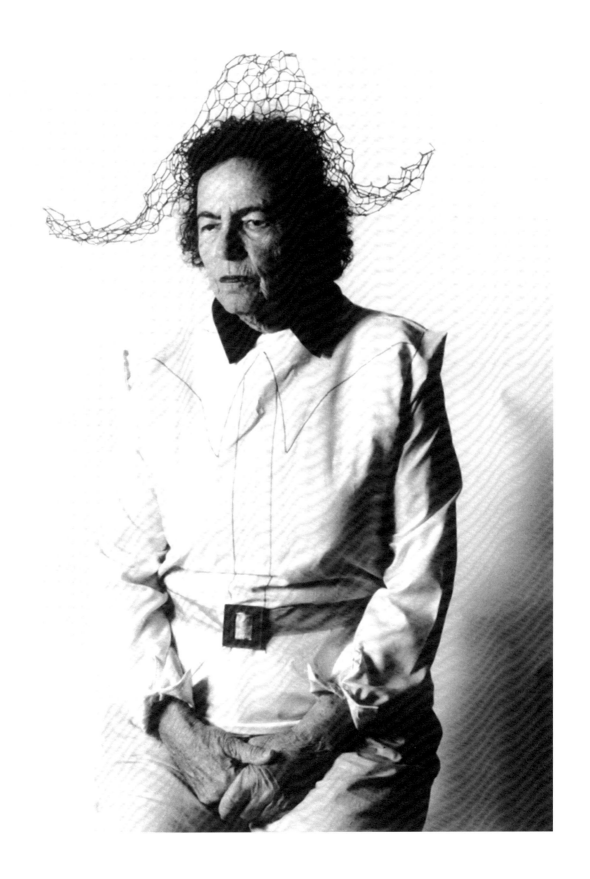

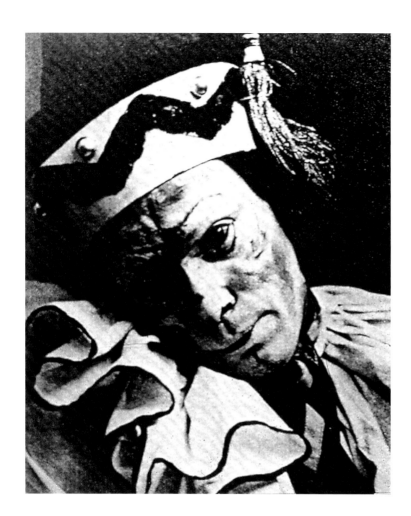 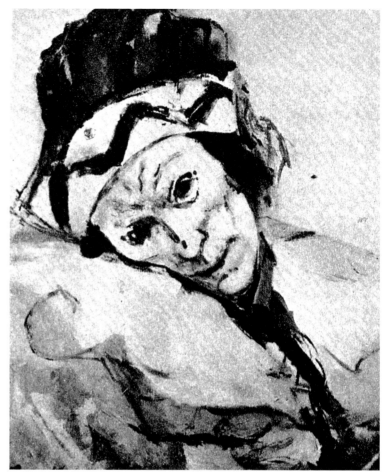

Hammond after Nijinsky

Elliott and Fry, Ltd., *Nijinsky as Petrouchka*, 1911. Franz Kline, *Nijinsky as Petrouchka*, ca. 1948.

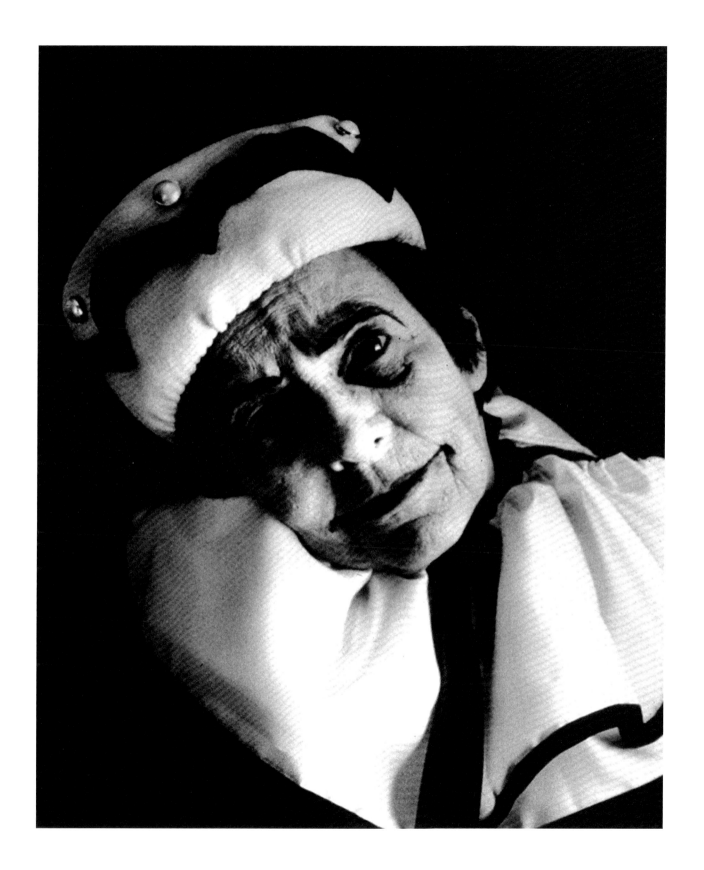

Hammond after Toulouse-Lautrec
96    Maurice Guibert, *Portrait of Henri de Toulouse-Lautrec*, ca. 1891.

(to be taken)

Hammond after Friedlander
Lee Friedlander, *Self-Portrait*, Philadelphia, 1965.
98    Courtesy Fraenkel Gallery, San Francisco.

(to be taken)

99

# Hammond Canonized

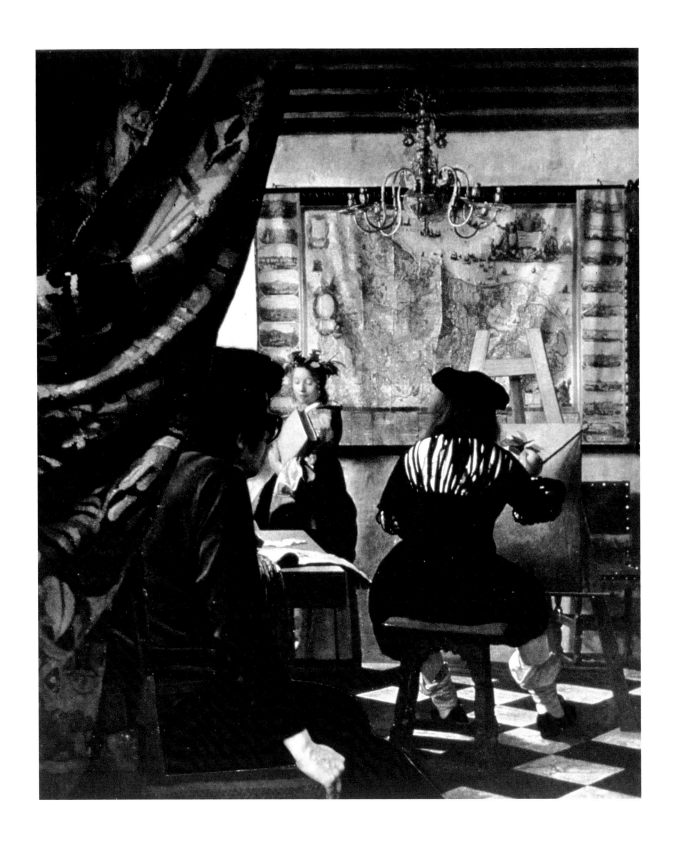

Hammond with Vermeer

Johannes Vermeer, *The Art of Painting*, ca. 1666.

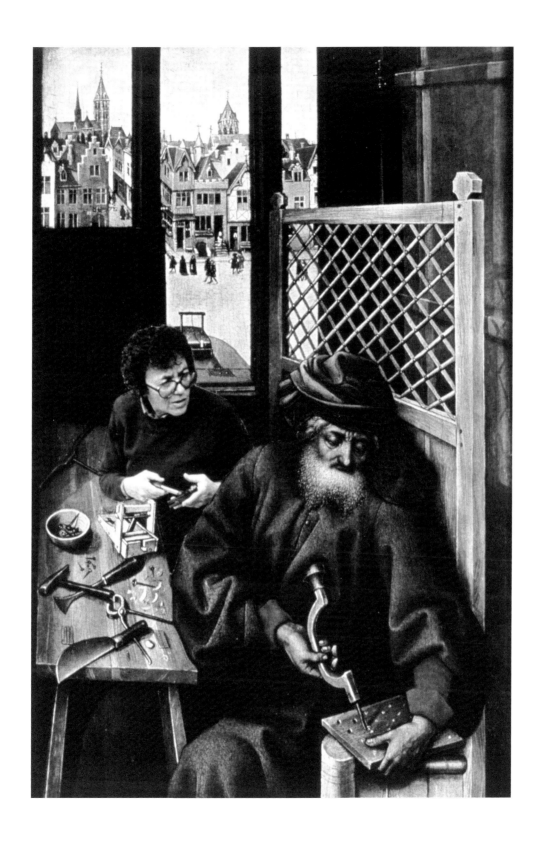

Hammond with Campin

Robert Campin, detail from *The Annunciation Triptych (The Merode Altarpiece)*, ca. 1422.

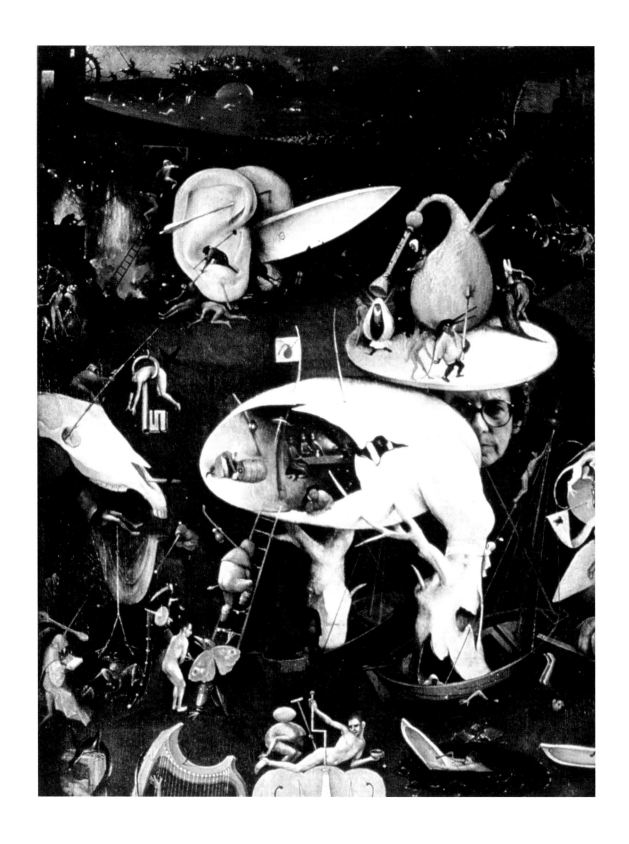

Hammond with Bosch

Hieronymus Bosch, detail of Hell from *The Garden of Delights*, ca. 1485.

Hammond with Seurat

Georges Seurat, *A Sunday Afternoon on the Island of La Grande Jatte*, 1884–86.

Hammond with Gérôme

Jean Leon Gérôme, *Duel after a Masked Ball*, 1857.

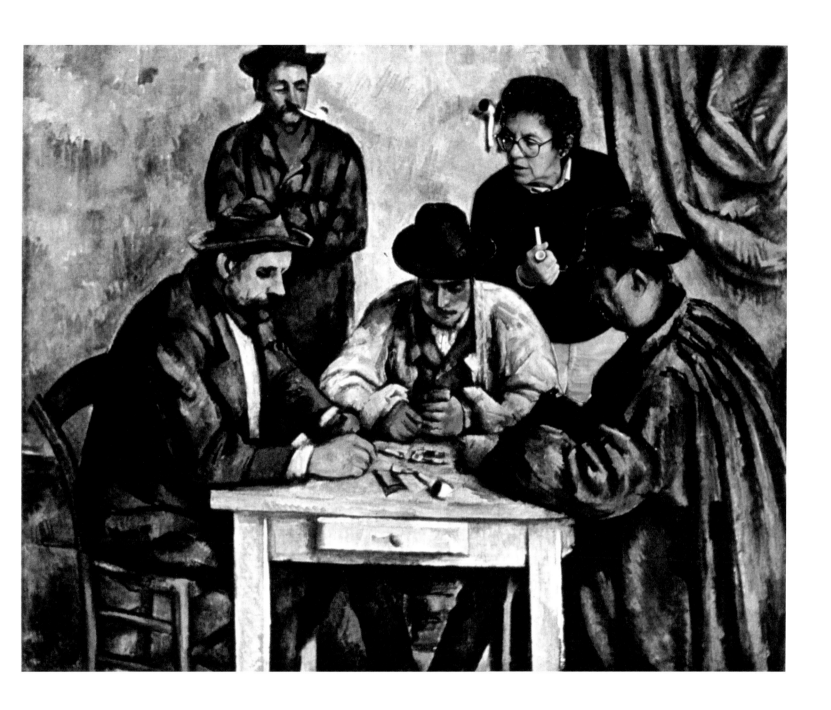

Hammond with Cézanne
Paul Cézanne, *The Card Players*, ca. 1890.

Hammond with Sargent
John Singer Sargent, *The Wyndham Sisters: Lady Elcho, Mrs. Adeane, and Mrs. Tennant,* 1899.

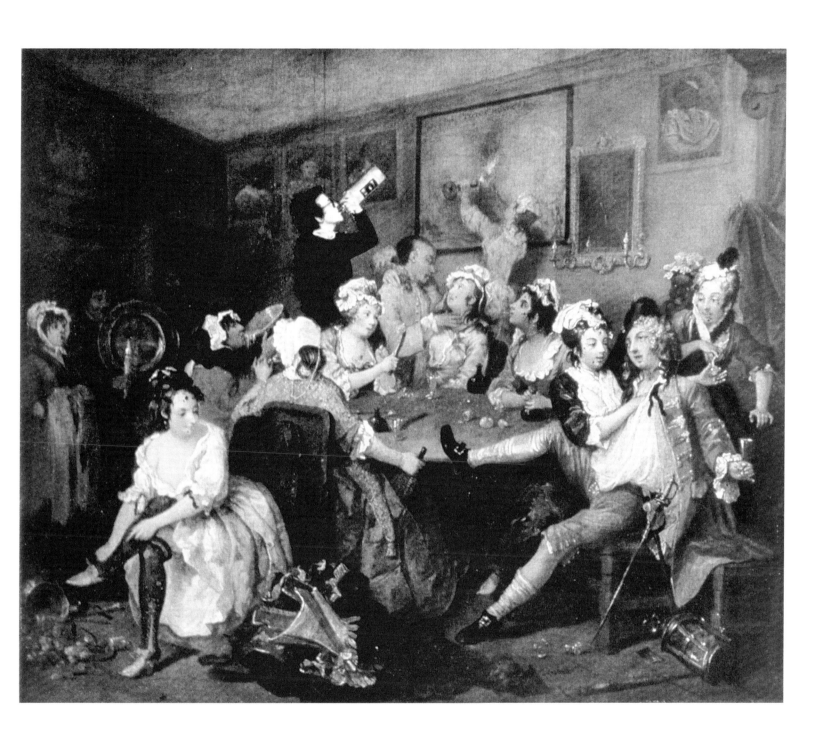

Hammond with Hogarth

William Hogarth, *A Rake's Progress*, 1735.

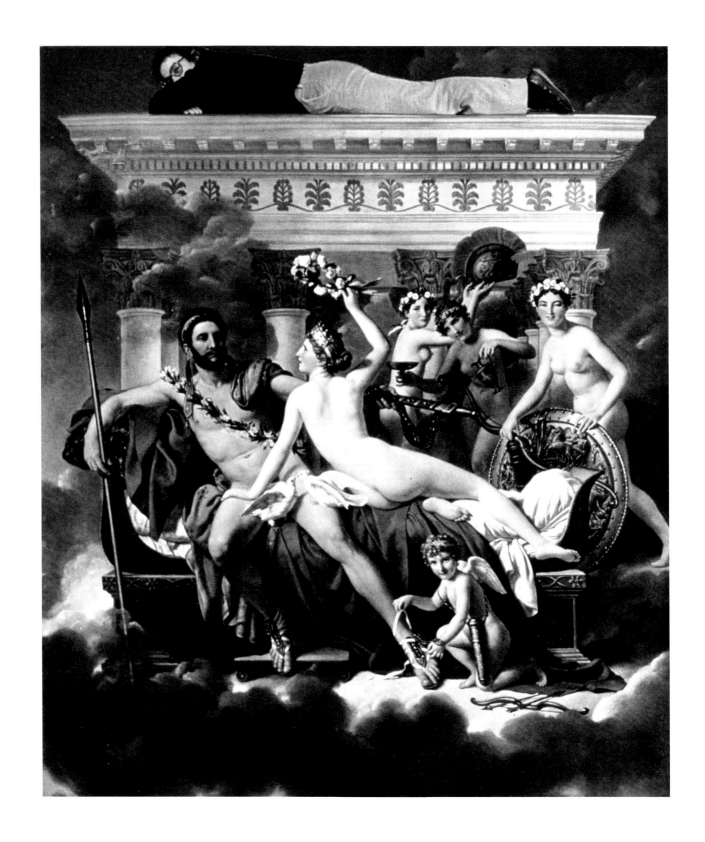

Hammond with David
Jacques-Louis David, *Mars Disarmed by Venus and the Graces*, 1824.

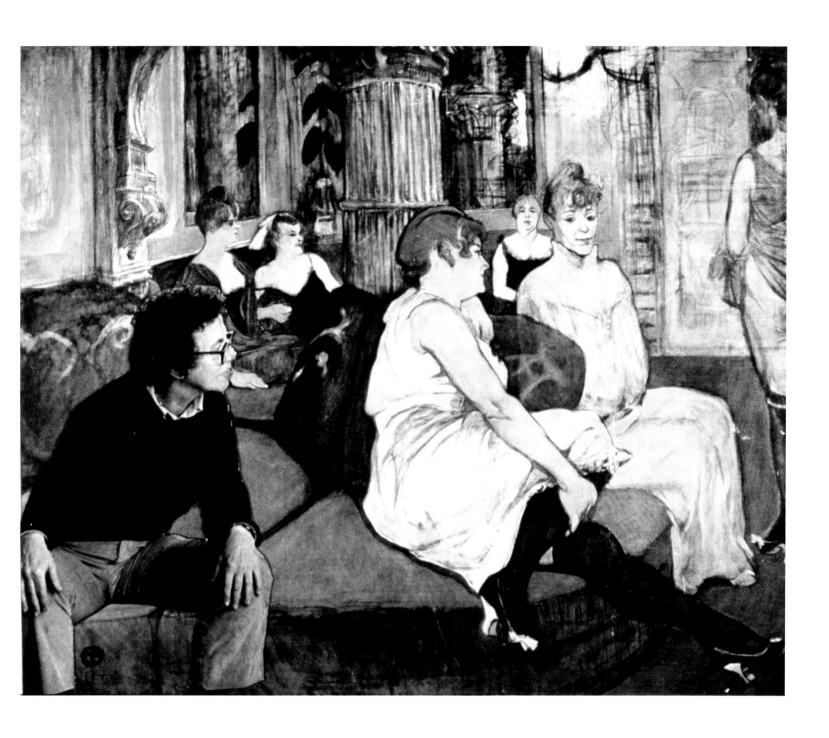

Hammond with Toulouse-Lautrec
Henri de Toulouse-Lautrec, *In the Salon at the Rue des Moulins*, 1894.

Hammond with Manet
Édouard Manet, detail from *Portrait of George Moore*, 1878–1879.

Hammond with Picasso
Pablo Picasso, *Les Demoiselles d'Avignon*, 1907.

Hammond with Bellini

Giovanni Bellini, *The Feast of the Gods*, 1514.

Hammond with Degas

Hilaire-Germaine-Edgar Degas, *Dance Class at the Opéra*, 1872.

*Celebrity*

Anne Sexton (1928–1974), American poet

Ishmael Reed (1938– ), American novelist, poet, essayist

120        Olga Broumas (1949– ), American poet

W. D. Snodgrass (1926– ), American poet, essayist

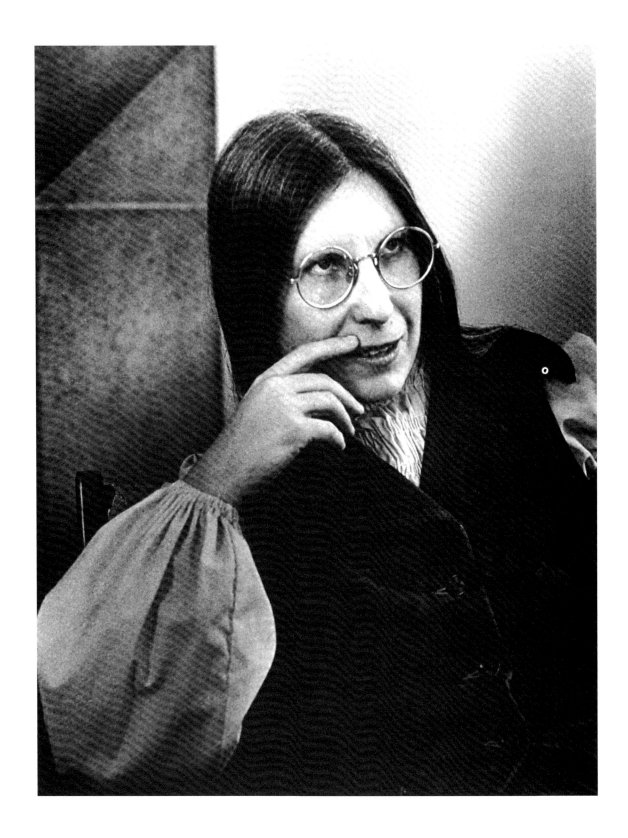

Diane Wakoski (1937– ), American poet, literary critic

Ralph Ellison (1914–1994), American novelist, essayist

Oren Lyons (1930– ), Faithkeeper of The Turtle Clan, Onondaga Nation; environmental leader

Adrienne Rich (1929– ), American poet, essayist

126            Leslie Fiedler (1917– ), American literary critic, novelist

Jill Johnston (1929– ), British art critic, philosopher 127

Robert Graves (1895–1985), British poet, novelist, essayist

Ritchie Havens (1941– ), American musician

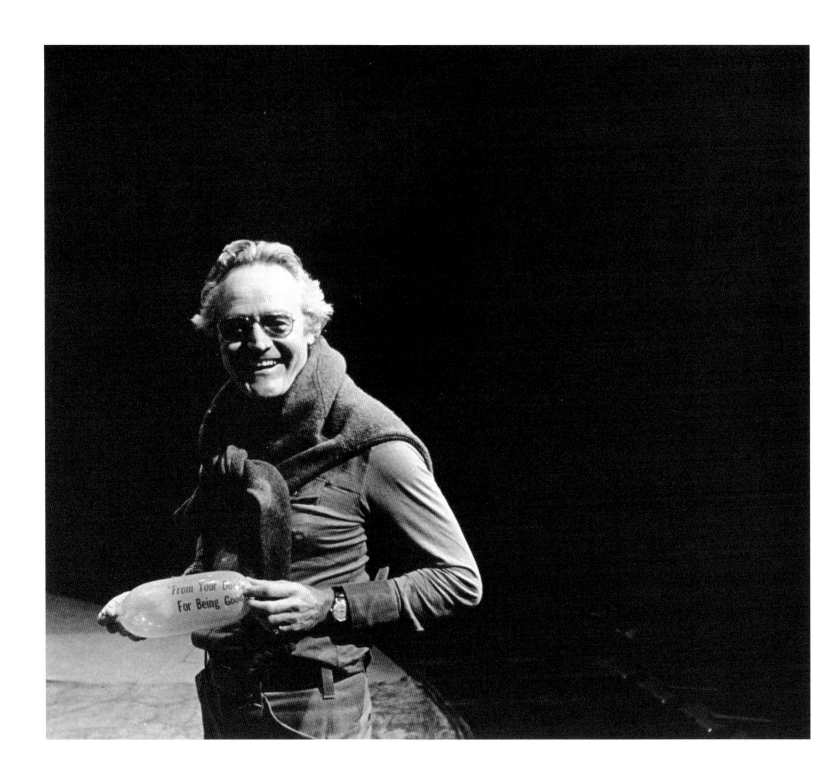

130     Jack Lemmon (1925–2001), American actor

Robert Kennedy (1925–1968), U.S. Attorney General, U.S. Senator

# *Afterword*

DEBORAH BRIGHT

I arrived late in Rita Hammond's life, at the very end of my 1996 Light Work residency in Syracuse. I had been hot on Rita's trail since I had seen her work reproduced in the 1995 Menschel Gallery catalog. I was also in the final stages of researching work for a book on photography and sexuality, *The Passionate Camera* (1998). Intrigued by the project, she invited me to Cazenovia for dinner and to look through her photographs. I had always intended to return to Cazenovia and see her again, but three more years slipped by and Rita was gone. I thought of the Leica she'd brandished with a triumphant grin as we stood in her comfortably cluttered studio. "I'm going to bronze it for my tombstone," she laughed—the laugh of a life in love with photography and its mischievous ways that matched her own.

Cross-generational inclusion has not been one of the hallmarks of the new "queer studies," much less of the ruthless calculus of an art marketplace that traffics in fashion and youth. The Menschel Gallery catalog brought Rita Hammond's work to the attention of the wider photographic community served by Light Work's estimable mailing list. The catalog exploded with the energy of a restless wit; Rita Hammond, in the guise of Nadar's famous mime, graced the front cover and sported Gap khakis on the back in a sendup of the apparel maker's nostalgic ad campaign. In between were almost thirty years of pictures about pictures: evidence of an instinctive postmodern consciousness *avant la lettre.*

But Rita had little truck with postmodernist theory. She took a visceral pleasure in her pictorial poachings and was less concerned with critiquing ideas of originality than with reinvigorating enduring cultural icons through her own carnivalesque identifications with them. Proudly inscribed on her aging female body, these personae are not mere exercises in simulation but dynamic expressions of a late-middle-aged woman's vigorously erotic subjectivity and sense of entitlement to history's stage.

In a society that is squeamish (at best) about overt expressions of older women's desires and fantasies, Rita's work insists on their palpable visibility. As a lover of women, she could outgun the macho painters at their own game. She also flirted shamelessly with the boys. As the seasoned veteran, she could give pointers to pretty Robert Mapplethorpe, trying on his best James Dean stare. Rita charges many of her diptych poses with this sort of gravitas, and her craggy, time-etched features often upstage the youthful physiognomies of her sources, as in her homage to Louise

Brooks. Here, the exchange of sidelong gazes between the ingénue Brooks and a smoldering noir Rita—an exchange underscored by their mutually proffered cigarettes—threatens to ignite the very paper the photographs are printed on. But doffing her leather jackets, cigarette holders, and sailor hat, Rita is also the self-deprecating nude matron who giggles unabashedly at her comparison to Marilyn's creamy perfection and, more soberly, reckons with the wonder of time's passing.

Even as time was running out, Rita was cooking up plans for new projects. Her commitment to making her art was as refreshingly open and unmarred by self-doubt as anyone I have ever met. Having come to the artist's life in middle age, after raising a family, she knew with great conviction who she was and what she wished to accomplish. As I drove away from Rita's studio that one evening we spent together, I mentally added her to my personal roster of heroes. As I enter my third decade as a practicing artist, I need heroes like Rita Hammond to remind me of the importance of being stubborn, selfish, and consumed, above all else, with making those images the world needs to have—if only because we say so! Now, with the publication of this volume, a larger audience will become acquainted with Rita Hammond's photographic work and share the rich gifts of her enduring eye and wit.

Boston, Mass. 2001

# Annotated List of Source Images | CHARLES PALERMO

## A DUE VOCI

Hippolyte Bayard (1801–1887), *Self-Portrait as a Drowned Man* (Photograph; 1840). (p. 52)

Bayard's self-portrait stages a fictional suicide. In so doing, it dramatizes his frustrated claim for recognition as an inventor of photography. He wrote a text that appears on the back of one such rare print, which reads in part: "The corpse which you see here is that of M. Bayard, inventor of the process that has just been shown to you, or the wonderful results of which you will soon see" (Gernsheim 1982, 69). Toward its conclusion, the text turns again to the scene rendered on its front: "The Government, which has supported M. Daguerre more than is necessary, declared itself unable to do anything for M. Bayard and the unhappy man threw himself into the water in despair" (69). (Lo Duca [1943] 1979)

Hammond's photograph was produced in collaboration with Lynn Moser.

Virginia Oldoini, the Countess de Castiglione (1837–1899), and Pierre-Louis Pierson (1822–1913), *Scherzo di Follia* (Photograph; 1861–67). (p. 54)

Virginia Oldoini was born into a prominent Italian family and married Count Francesco Verasis de Castiglione (1826–1867). The count was close to the court of Victor-Emmanuel II of Savoy, King of Sardinia and Piedmont. In 1855, the count and countess moved to Paris, ostensibly to visit the countess's cousin, Marie-Anne Walewska, who was a member of court society in the French capital. The countess had, however, also been secretly charged by Victor-Emmanuel's minister, Cavour, with advocating at the French court on behalf of Savoy's attempt to unify Italy. The countess began a series of friendships and affairs that linked her to the most prominent persons in Parisian society. At the same time, she began staging elaborate and dramatic portraits in collaboration with her favorite portrait photographer, Pierre-Louis Pierson, a principal in the photographic firm of Mayer & Pierson. The title of this whimsical collaborative self-portrait (which is among her most famous) appears to have been inspired by Verdi's opera *Un ballo in maschera*. (*La Comtesse de Castiglione par elle-même*, 1999–2000)

Hilaire-Germaine-Edgar Degas (1834–1917), *Woman with Field Glasses* (Pencil and essence on paper mounted on canvas; 1869–72). (p. 56)

This is one of a series of pictures of the same subject—a female figure gazing directly out of the picture through binoculars. The figure is assumed to have been intended for a larger composition showing a crowd at a racetrack, but never found its way into a finished painting on that theme. There has been some speculation about the mysterious sitter's identity, which appears to have been known once, at least among those who knew Degas personally. (Boggs 1988–89; Lemoisne 1947)

Alexander Gardner (1821–1882), *Paine on the Saugus, April 27, 1865* (Photograph; 1865). (p. 58)

The subject is Lewis Thornton Paine, one of the conspirators in the plot to assassinate President Abraham Lincoln, shortly after he was taken into custody and imprisoned aboard the U.S.S. *Saugus*. Paine's task in the plot was to kill Secretary of State William H. Seward, who was home in bed the night John Wilkes Booth shot the president. Gardner's photographs of the prisoners held on the *Saugus* and on the U.S.S. *Montauk* were pioneering efforts in what came to be known as the mug shot. Further, Paine appears to have been Gardner's favorite sitter—he made more exposures of Paine than he did of the other suspects, and some of the pictures of Paine were the only efforts from the project that Gardner registered for copyright. (Katz 1991)

Still photograph, Louise Brooks. Courtesy of Phototheque Cinematheque Suisse. Droits réserves. (p. 60)

Brooks (1906–85) was a silent film star, most famous for her portrayal of the femme fatale "Lulu" in Georg Wilhelm Pabst's *Pandora's Box* (1929). Her sexy screen persona made her one of the greatest stars of the 1920s and one of the most enduring names and faces of the flapper era.

Hammond's photograph was produced with the assistance of Priscilla Van Deusen.

Jean-Baptiste-Siméon Chardin (1699–1779), *The Soap Bubble* (Oil on canvas; ca. 1733). (p. 62)

Chardin's mastery of the drama of ordinary life made him one of the most sought-after painters of his day. *The Soap Bubble* derives its life from the fragility of the soap bubble and the breathless attention that property excites in the two pictured figures—and in the beholder. The theme of the soap bubble is often read as a *vanitas*—that is, as a comment on the worthlessness and evanescence of our worldly pursuits—but its power and Chardin's genius lay in his ability to construct a fiction so vivid and taut that his audience could lose itself completely in the boy's anticipation. (Fried 1988)

Andy Warhol (1928–1987), *Self-Portrait with Skull* (Polaroid photograph; 1977). Copyright © 2002 Andy Warhol Foundation for the Visual Arts / Artists Rights Society (ARS), New York. (p. 64)

For portraits and self-portraits, Warhol routinely used a Polaroid "Big Shot" camera, as he did for this self-portait. (Warhol 1992)

Jean-Louis-André-Théodore Géricault (1791–1824), *Portrait of a Young Man in an Artist's Studio* (Oil on canvas; 1819–20). (p. 66)

Géricault painted this work in a difficult period following the success and the disappointment that attended the *Raft of the Medusa*'s debut at the Salon of 1819. Géricault was ill and troubled, and he retreated from Paris. This work was called a self-portrait for many years, even though it does not bear Géricault's features. (Eitner 1983)

Max Beckmann (1884–1950), *Self-Portrait in Sailor Hat* (Oil on canvas; 1926). Copyright © 2002 ARS, New York / VG Bild-Kunst, Bonn. (p. 68)

Beckmann painted numerous important self-portraits. This one dates to the period of his great, early success, during which he lived in Frankfurt and frequented high society. (Lackner 1991)

Hammond's photograph was produced in collaboration with Kim Waale.

Eve Arnold (b. 1934), *Marilyn Monroe (Studio Session)* (Photograph; 1960). Reproduced with permission by Magnum Photos. (p. 70)

Arnold photographed Monroe numerous times during the latter's career, and the two became friends. This image is from one of their later sittings. It was shot in Arnold's studio in response to requests from the press for publicity photographs. (Arnold 1987)

In this diptych Hammond used a photograph taken in 1984 by Ray Beale.

Robert Mapplethorpe (1946–1989), *Self-Portrait [with cigarette]* and *Self-Portrait [in drag]* (Photographs; 1980). (pp. 72,74)

Robert Mapplethorpe's explicit treatment of gender and sex made his work a scandal and a cause for those concerned with public funding and freedom of expression in the art world.

Hammond's photographs were produced in collaboration with Ray Beale and with the assistance of Priscilla Van Deusen.

Laurence Sudre, *Joseph Beuys* (Photograph). (p. 76)

Joseph Beuys's shamanistic enterprise—which he affiliated for some time with the *Fluxus* movement, but which is otherwise notoriously difficult to classify—turned around a complicated personal mythology that Beuys invented for himself. Materials such as felt and fat were persistent features of Beuys's art—motifs lifted from an apocryphal autobiographical tale, according to which Beuys, flying in a German Stuka aircraft during World War II, crashed in Russia and was rescued by Tartars who wrapped him in the felt and fat to keep him warm. (Moffitt 1988)

Edvard Munch (1863–1944), *Self-Portrait with Skeleton Arm* (Lithograph, printed in black, composition: 18⅛ × 12¾ in. [46.1 × 32.4 cm]; 1895, signed 1896). (p. 78)

Munch drew this self-portrait while he was at the height of his powers, working through influences and experiences he had encountered in Paris and Berlin, and especially assimilating a dark, symbolist sensibility from contacts with artists such as Strindberg and Mallarmé. During the mid-1890s, Munch was newly and intensely involved in print media. (Selz 1974)

Nadar (Félix Tournachon) (1820–1910), *Banker's Hand* (Photograph [albumen print, masked to an oval]; 1861). (p. 80)

Originally published in the catalogue of the fourth exhibition of the Société Française de Photographie in Paris in 1861, and titled *La Main du banquier D\*\*\** (*The Hand of the Banker D\*\*\**), this photograph demonstrates Nadar's interest in physical types, and specifically in the shape of hands. The photograph also exemplifies Nadar's early interest in the use of electric light for photography; its title bore the explanatory note "*tirée en une heure à la lumière électrique*" ("taken in one hour in electric light"). (Hambourg, Heilbrun, and Néagu 1995)

Hammond's photograph was produced in collaboration with Lynn Moser.

Nadar (Félix Tournachon) (1820–1910) and Adrien Tournachon (1825–1903), *Pierrot the Photographer (Charles Deburau as Pierrot)* (Photograph [gelatin-coated salted paper print]; 1854–55). (p. 82)

Nadar wrote plays for the famous actor Jean-Baptiste-Gaspard Deburau until Deburau's son, Charles, took his father's place at the Théâtre des Funambules as Pierrot, a traditional character adapted from the Comédie Italienne. This photograph comes from a series, *Études d'expression de Charles Deburau en Pierrot*, in which the younger Deburau struck expressive poses in costume. The photograph is signed "Nadar *jeune*," indicating that it was taken by Adrien Tournachon (the famous Nadar's younger brother, who worked with his older, more productive brother from time to time), but it is now thought that the series was likely a cooperative effort between the brothers. The series excited great popular and critical interest at the Exposition Universelle of 1855. Indeed, it has been suggested that Deburau's expressive poses inspired a scientific series along similar lines published by Dr. Guillaume-Benjamin-Amand Duchenne de Boulogne (1806–1875) in his *Mécanisme de la physionomie humain; ou analyse électro-physiologique de l'expression des passions* (1862). If so, then the Deburau series may have helped in the rise of a scientific genre that culminated in Charcot's famous study of hysteria. (Hambourg, Heilbrun, and Néagu 1995; Duchenne de Boulogne 1862; Roth 1991)

Hammond's photograph was produced with the assistance of Karen Steen.

Ilse Bing (1899–1998), *Self-Portrait with Leica* (Photograph; 1931). Courtesy Edwynn Houk, Advisor, The Estate of Ilse Bing. (p. 84)

For this, her most famous photograph, Bing used film that was sensitive to blue light—and not to red—to accentuate certain forms, such as lips. The image is reversed, and the camera points out of the photograph, creating an impression of irreality, which Bing intended: "Left and right are inverted. What is my left arm appears as though it were my right, and vice versa. Thus the image of myself is not the truth; but the other reflection, which ought to conform to reality, is just...a reflection. Moreover, the two cameras one sees aim at a space beyond the image. So, where is the real space? Where, after all, is reality? Is it in this image? Beyond? It's a little like *Alice in Wonderland*, reality begins only behind the surface of the mirror" (*Ilse Bing, Paris 1931–1952* 1987–88, cat. no. 1, 98; my translation).

René Magritte (1898–1967), *The Human Condition ("La Condition humaine")* (Oil on canvas; 1933). Copyright © 2002 C. Herscovici, Brussels / ARS, New York. (p. 86)

Several of Magritte's works bear this title. Even more of them elaborate on this theme: that of reality and representation (figured here by the canvas on an easel before a window) conflated. In a talk written several years after this work was painted ("La Ligne de vie" 1938), the prominent Belgian surrealist explained the line of research that led to it. He started with an account of his earlier approach to conceiving paintings:

"The basic device was the placing of objects out of context: for example, a Louis-Philippe table on an ice-floe. . . .

"The creation of new objects, the transformation of known objects; a change of substance in the case of certain objects: a wooden sky, for instance; the use of words in association with images; the misnaming of an object; the development of ideas suggested by friends; the use of certain visions glimpsed between sleeping and waking, such in general were the means devised to force objects out

of the ordinary, to become sensational, and so to establish a profound link between consciousness and the external world."

He continued, describing more recent developments in his practice, especially a desire to bring together things with a previously obscure affinity. This is the line of research that produced *The Human Condition*: "In the course of my research, I became certain that the element to be discovered, the unique feature residing securely in each object, was always known to me in advance, but that my knowledge of it was, so to speak, hidden in the depths of my thought.

"As my research had necessarily to arrive at a single correct answer for each object, my investigation took the form of trying to find the solution of a problem with three points of reference: the object, the something linked to it in the obscurity of my consciousness and the light into which this something had to be brought....

"The problem of the window gave rise to *The Human Condition*. In front of a window seen from the inside of a room, I placed a picture representing exactly the section of the landscape hidden by the picture. The tree represented in the picture therefore concealed the tree behind it, outside the room. For the spectator, it was both inside the room and in the picture and, at the same time, conceptually outside in the real landscape. This is how we see the world, we see it outside ourselves and yet the only representation we have of it is inside us. Similarly, we sometimes place in the past something which is happening in the present. In this case, time and space lose that crude meaning which is the only one they have in everyday experience" (Ottinger-Zingue and Lean 1998, 46–47). (Meuris 1989)

Asher Brown Durand (1796–1886), *Kindred Spirits* (Oil on canvas; 1849). (p. 88)

The great landscape painter Thomas Cole died in 1848. His friend William Cullen Bryant delivered a "Funeral Oration" in his honor before the National Academy. In honor of the tribute, Asher Brown Durand's patron Jonathan Sturges commissioned this painting and presented it to Bryant. It shows Cole and Bryant (whose names are inscribed on a tree in the left foreground) surveying the kind of awe-inspiring vista that typified Cole's work and that of the painters of the Hudson River School who followed him. (Lawall 1966)

Hammond's photograph was produced in collaboration with Lynn Moser.

Paul Gauguin (1848–1903), *Meyer de Haan* (Oil on wood; 1889). (p. 90)

De Haan was a Dutch mystic and a friend of the post-impressionist during his stays at Pont-Aven and Le Pouldu. He is shown here with copies of Carlyle's *Sartor Resartus* and Milton's *Paradise Lost*. (Cachin 1990)

Pablo Picasso (1881–1973), *Seated Harlequin (Portrait of the Painter Jacinto Salvado)* (Oil on canvas; 1923). Copyright © 2002 Estate of Pablo Picasso / ARS, New York. (p. 92)

Picasso painted his friend Salvado several times in a harlequin costume provided by Jean Cocteau. The works typify Picasso's postwar classicizing phase, in which he pastiched traditional painting. The figure of Harlequin was Picasso's perennial alter ego. (Warnke 1995)

Hammond's photograph was produced in collaboration with Kim Waale.

Elliott and Fry, Ltd., *Nijinsky as Petrouchka* (Photograph; 1911). (p. 94)

This photograph shows the great Russian dancer Nijinsky in what his wife later called his favorite role, the man-puppet Petrouchka. The role, she explained in her biography of the dancer, "grew on him as he became more and more used to it; and the longer he danced it the more monumental was his conception" (Nijinsky 1934, 127).

Franz Kline (1910–1962), *Nijinsky as Petrouchka* (Oil on canvas; ca. 1948; Collection of Mr. and Mrs. I. David Orr). Copyright © 2002 The Franz Kline Estate / ARS, New York. (p. 94)

Kline first encountered a reproduction of Elliott and Fry's photograph of the great dancer Nijinsky as Petrouchka in London in 1936. It remained available to him in his copy of Romola Nijinsky's 1934 biography of her husband. He appears to have identified with the dancer's interpretation of the character and, throughout the period preceding his turn to abstraction, made at least six versions of it, including this, which (despite Kline's very personal involvement with the theme) was painted as a commission for David Orr. (Gaugh 1985–96)

Maurice Guibert (1854–1913), *Portrait of Henri de Toulouse-Lautrec* (Photograph; ca. 1891). (p. 96)

Guibert was a champagne merchant, bon vivant, painter and photographer. He accompanied the similarly high-living Toulouse-Lautrec (1864–1901) on numerous adventures and even directly assisted him in completing a painting. Guibert occasionally sat for Toulouse-Lautrec but also took several photographic portraits of his friend, including this trick photo, in which the artist's image is exposed twice—once as portraitist and once as sitter. In the postcard that provided Hammond with her source image, the photograph was labeled as a self-portrait, which certainly complicates the possibilities for the self-representation Hammond anticipates in her "to be taken." (Arnold 1982; Frey 1994; Toulouse-Lautrec 1973)

Lee Friedlander (b. 1934), *Self-Portrait, Philadelphia* (Photograph; 1965). (p. 98)

Friedlander is particularly known for his self-portraits. They can be playfully inventive or, as in this case, stunningly frank. He grew up in Washington State, studied briefly in Los Angeles, then moved to New York and again just north of New York. His photographs explore the American landscape with intense candor and his work is often classed with that of Diane Arbus and Garry Winogrand. (Friedlander 1989)

## HAMMOND CANONIZED

Johannes Vermeer (1632–1675), *The Art of Painting* (Oil on canvas; 1666–67). (p. 102)

Vermeer transforms an artist's studio into the setting of an allegory. The artist's space is separated from the beholder's by a loop of curtain that seems to mark the threshold of a fictive space. A chair straddles that threshold, while the artist's turned back alludes to the separation it suggests. The woman who sits for the painting is dressed as Clio, the muse of history, and a map on the far wall of the studio represents the Netherlands. A softening of detail in places (see, for

example, the patterned cloth) evokes the effects of the camera obscura, a device similar to our modern photographic camera (without the film) that some believe Vermeer used to attain the high degree of verisimilitude characteristic of his work. (*Johannes Vermeer 1995–96; Wheelock 1981*)

**Robert Campin** (ca. 1378–1445), detail from *The Annunciation Triptych (The Merode Altarpiece)* (Oil on wood; ca. 1422). (p. 103)

Although the altarpiece was attributed to the "Master of Flemalle" (the kind of name that is devised to supply a hypothetical identity for the creator of a body of works, in the absence of a name) for years, it is now assigned to Robert Campin. The right-hand wing of the altarpiece (shown here) depicts St. Joseph at work in his shop, while in the center panel Gabriel announces the Incarnation to the Virgin Mary. (Châtelet 1996)

**Hieronymus Bosch** (ca. 1450–1516), detail of Hell, from *The Garden of Delights* (Oil on panel; ca. 1485). (p. 104)

Bosch's enigmatic triptych shows Eden, an earthly realm, and Hell, each crowded with symbolic and vivid scenes. It has been suggested that the strange world of *The Garden* is informed by the heretical teachings of the Adamites, who advocated sexual freedom. The panel shown here is a terrible mixture of signs and vignettes representing and caricaturing folly (especially through musical symbols), ignorance, and cruelty and combining them with supernatural tortures. (Musper 1981)

**Georges Seurat** (1859–1891), *A Sunday Afternoon on the Island of La Grande Jatte* (Oil on canvas; 1884–86). (p. 105)

Seurat's masterpiece shows his "divisionist" technique—a screen of small, brilliant, contrasting touches of paint applied over more broadly brushed areas of color—in its full flower. The technique, derived from the nineteenth century's advancing understanding of the mechanics of visual perception, discouraged mixture of pigments on the palette and even on the canvas, in favor of "optical mixture," whereby the beholder's eye combines the pure colors into subtler tones. Despite his devotion to the technique of painting, Seurat studied nature intensely, visiting the site daily for months and completing dozens of studies in preparation for the large and diverse composition. (Rewald 1946)

**Jean Leon Gérôme** (1824–1904), *Duel after a Masked Ball* (Oil on canvas; 1857). (p. 106)

Although Gérôme is primarily known for his orientalist themes as well as his later interest in sculpture, this painting represents the artist's penchant for melodrama and his interest in narrative representation. A student of Paul Delaroche, Gérôme remained aloof from vanguard and experimental art emerging in France during the nineteenth century. It should be noted that Hammond showed a recurring interest in the figure of Pierrot and in other characters derived from the commedia dell'arte.

**Paul Cézanne** (1839–1906), *The Card Players* (Oil on canvas; 1890–92). (p. 107)

Cézanne painted a series of closely related pictures of men playing cards; all of these works were painted within a few years of one another. This image, from the Metropolitan Museum of Art in New York, is thought to be one of the earlier treatments of the theme. The series is outstanding both for its strong, classical composition

and for its sensitive expressivity; in fact, it is exceptional within Cézanne's oeuvre for combining a multifigure composition with the use of models (usually, Cézanne painted single models alone, or worked from imagination or photographs). (*Cézanne 1996; Verdi 1992*)

**John Singer Sargent** (1856–1925), *The Wyndham Sisters: Lady Elcho, Mrs. Adeane, and Mrs. Tennant* (Oil on canvas; 1899). (p.108)

The three daughters of the Hon. Percy Wyndham posed for the premier society portraitist of the generation; in the background is a portrait of their mother by George F. Watts. (Fairbrother 1994)

**William Hogarth** (1697–1764), *A Rake's Progress* (Oil on canvas; 1735). (p. 109)

Hogarth's series on the life of a rake tells the story of a son of a frugal family of the merchant class who turns to a dissolute life. Hogarth published his series in the form of engravings, earning money on their popularity. The tremendous success of engravings after Hogarth's narrative cycles inspired unauthorized imitations, which in turn led Hogarth to campaign (successfully) for a copyright law to cover engravings. (Paulson 1975)

**Jacques-Louis David** (1748–1825), *Mars Disarmed by Venus and the Graces* (Oil on canvas; 1824). (p. 110)

The subject is traditional (except for the addition of the Graces) and characterizes David's later style in its elegance. (In fact, the elongated grace of the figures suggests comparison with the works of David's student, Ingres.) David painted *Mars Disarmed* in Brussels, where he lived after Napoleon's fall, but the picture was exhibited privately to paying viewers in Paris, where it was much acclaimed. (Lévêque 1989)

**Henri de Toulouse-Lautrec** (1864–1901), *In the Salon at the Rue des Moulins* (Oil on canvas; 1894). (p. 111)

Toulouse-Lautrec took Parisian nightlife—and especially its intimate, darker side—as his prime subject matter. This view shows women awaiting clients in an upscale brothel. (Toulouse-Lautrec 1973)

**Édouard Manet** (1832–1883), detail from *Portrait of George Moore* (Oil on canvas; 1878–1879). (p. 112)

The English novelist Moore lived and studied in Paris during the years when impressionism came into its own. Manet, the great predecessor of the impressionists who later assimilated their style, painted this portrait toward the end of his career. Later, in an essay that became a chapter in his *Modern Painters*, Moore wrote: "The color of my hair never gave me a thought until Manet began to paint it. Then the blonde gold that came up under his brush filled me with admiration, and I was astonished when, a few days after, I saw him scrape off the rough paint and prepare to start afresh.

"'Are you going to get a new canvas?'

"'No; this will do very well.'

"'But you can't paint yellow ochre on yellow ochre without getting it dirty?'

"'Yes, I think I can. You go and sit down.'

"Half-an-hour after he had entirely repainted the hair, and without losing anything of its brightness. He painted it again and again; every time it came out brighter and fresher, and the painting never seemed to lose anything in quality."

It was that quality—Manet's ability to renew the freshness in an oil

painting—that most struck Moore: "Ah! that marvellous hand, those thick fingers holding the brush so firmly—somewhat heavily; how malleable, how obedient, that most rebellious material, oil-colour, was to his touch. He did with it what he liked. I believe he could rub a picture over with Prussian blue without experiencing any inconvenience; half-an-hour after the colour would be fine and beautiful" (Moore 1923, 26–27). (Cachin 1991)

Pablo Picasso (1881–1973), *Les Demoiselles d'Avignon* (Oil on canvas; 1907). (p. 113)

Picasso's eclectic and disturbing early masterpiece is sometimes described as the crowning achievement of his pre-cubist exploration of the morphology of African masks and sometimes as the inaugural work of cubism. The *Demoiselles* was the result of an intense campaign involving a series of studies that transformed the original brothel scene; the men whom he first positioned as spectators before the prostitutes found themselves replaced by the up-ended table corner, which marks the position of the beholder before the whores in the painting (and thereby collapses the customer's role into the beholder's). (Steinberg 1972)

Giovanni Bellini (ca. 1430–1516), *The Feast of the Gods* (Oil on canvas; 1514). (p. 114)

Giovanni is the most celebrated member of an artistic family that operated a successful workshop in Venice. Titian, a younger artist in the world of the Bellini, added the wild landscape at the left of the composition. The scene was commissioned by Duke Alfonso d'Este of Ferrara and is based on the story of the lotus tree in Ovid's *Fastii* (and related again, in more summary form, in his *Metamorphoses*). Priapus lifts the hem of Lotis's skirt shortly before she is to be transformed into the lotus tree. (Goffen 1989)

Hilaire-Germaine-Edgar Degas (1834–1917), *Dance Class at the Opéra* (Oil on canvas; 1872). (p. 115)

Degas shows a dance class in authentic circumstances and under the supervision of its master Louis Mérante. The dancers, a frequent subject for Degas from the early 1870s and throughout much of his career, leave their exercises to take the master's instruction. As usual, Degas's selection of a transitional movement, one depicting not a unified action but the loosely coordinated movements of several figures, invites the beholder to assume the place of the unobserved witness of a perfectly candid moment. (Boggs 1988–89)

# Works Cited

Apraxine, Pierre, and Xavier Demange. 2000. *"La Divine Comtesse": Photographs of the Countess de Castiglione*. New Haven: Yale Univ. Press in association with The Metropolitan Museum of Art.

Arnold, Eve. 1987. *Marilyn Monroe: An Appreciation*. New York: Knopf.

Arnold, Matthias. 1982. *Henri de Toulouse-Lautrec in Selbstzeugnissen und Bilddokumenten*, Rowohlts Monographien, herausgegeben von Kurt und Beate Kusenberg. Reinbek bei Hamburg: Rowohlt.

Bakhtin, Mikhail. 1968. "Introduction." In *Rabelais and His World*. Translated by Helene Iwolsky. Cambridge, Mass.: MIT Press.

Barthes, Roland. 1981. *Camera Lucida*. New York: Hill and Wang.

Bernstein, Howard. 2001. Telephone interview by Ann M. Ryan. September.

Boggs, Jean Southerland. 1988–89. *Degas*. Ex. cat., Galeries Nationales du Grand Palais, Paris; National Gallery of Canada, Ottowa; The Metropolitan Museum of Art, New York.

Bright, Deborah, ed. 1998. *The Passionate Camera: Photography and Bodies of Desire*. New York: Routledge.

Brooks, Louise. 1986. "An Answer to an Admirer" (letter to Guido Crepax, 1976). In *Louise Brooks: Portrait of an Anti-Star*, edited by Roland Jaccard, 143–44. New York: Zoetrope.

Butler, Judith. 1990. *Gender Trouble: Feminism and the Subversion of Identity*. New York: Routledge.

Cachin, Françoise. 1990. *Gauguin*. Translated by Bambi Ballard. Paris: Flammarion.

———. 1991. *Manet*. Translated by Emily Read. London: Barrie and Jenkins.

*Cézanne*. 1996. Ex. cat., The Philadelphia Museum of Art, Philadelphia; Galeries Nationales du Grand Palais, Paris; Tate Gallery, London.

Châtelet, Albert. 1996. *Robert Campin, Le Maître de Flémalle: La fascination du quotidien*. Anvers: Fonds Mercator.

Cixous, Hélène. 1981. "The Laugh of the Medusa." In *New French Feminisms*, edited by E. Marks and T. de Courtivron. New York: Harvester.

Clark, T. J. 1984. *The Painting of Modern Life: Paris in the Art of Manet and His Followers*. Princeton: Princeton Univ. Press.

*Comtesse de Castiglione par elle-même, La*. 1999–2000. Ex. cat., Paris, Musée d'Orsay.

Daly, Mary. 1978. *Gyn/Ecology: The Metaethics of Radical Feminism*. Boston: Beacon Press.

Doane, Mary Ann. 1991. *Femme Fatales: Feminism, Film Theory, Psychoanalysis*. New York and London: Routledge.

Duchenne de Boulogne, Guillaume-Benjamin-Amand. 1862. *Mécanisme de la physionomie humain; ou analyse électro-physiologique de l'expression des passions*. Paris: Vve de Jules Renouard.

Dyer, Richard. 1988. "Monroe and Sexuality." In *Women and Film*, edited by Janet Todd, 69–96. New York and London: Holmes and Meier.

Eitner, Lorenz. 1983. *Géricault: His Life and Work*. London: Orbis.

Eliot, T. S. 2000. "The Love Song of J. Alfred Prufrock." In *The Norton Anthology of English Literature*, vol. 2, 7th ed., edited by M. H. Abrams, 2364–67. New York and London: W. W. Norton and Co.

Elsaesser, Thomas. 1983. "Lulu and the Meter Man: Louise Brooks, Pabst, and 'Pandora's Box,'" *Screen* 24, nos. 4–5 (July–Oct.): 4–36.

Fairbrother, Trevor. 1994. *John Singer Sargent*. New York: Abrams.

Frank, Anne. 1989. *The Diary of Anne Frank: The Critical Edition*. Prepared by The Netherlands State Institute for War Documentation. New York: Doubleday.

Freud, Sigmund. 1960. *Jokes and Their Relation to the Unconscious*. Edited by James Strachey. New York: Norton.

Frey, Julia. 1994. *Toulouse-Lautrec: A Life*. New York: Viking.

Fried, Michael. 1988. *Absorption and Theatricality: Painting and Beholder in the Age of Diderot*. Berkeley: Univ. of California Press, 1980. Reprint. Chicago: Univ. of Chicago Press.

Friedlander, Lee. 1989. *Like a One-Eyed Cat: Photographs by Lee Friedlander, 1956–1987*. Text by Rod Slemmons. Ex. cat., Seattle Art Museum, Seattle.

Gaugh, Harry F. 1985–86. *The Vital Gesture: Franz Kline*. Ex. cat., Cincinnati Art Museum.

Gernsheim, Helmut. 1982. *History of Photography*. New York: Thames and Hudson. Quoted in Sapir, Michael. 1994. "The Impossible Photograph: Hippolyte Bayard's 'Self-Portrait as a Drowned Man.'" *Modern Fiction Studies (Autobiography, Photography, Narrative)* 40, no. 3 (fall): 619–29.

Goffen, R. 1989. *Giovanni Bellini*. New Haven: Yale Univ. Press.

Gray, Frances. 1994. *Woman and Laughter*. Charlottesville: Univ. Press of Virginia.

Hambourg, Maria Morris, Françoise Heilbrun, and Philippe Néagu. 1995. *Nadar*. Ex. cat., Musée d'Orsay, Paris; Metropolitan Museum of Art, New York.

Hammond, Rita. 1967. *Images of a Girl*. Photographic series exhibited at the Dana Arts Center, Colgate Univ., Hamilton, N.Y.

———. 1999. Interview by Julie Grossman, Ann M. Ryan, and Kim Waale. Seattle, Wash., April.

Hastie, Amelie. 1997. "Louise Brooks, Star Witness." *Cinema Journal* 36, no. 3 (spring): 3–24.

Hoesterey, Ingeborg. 2001. *Cultural Memory in Art, Film, Literature*. Bloomington and Indianapolis: Indiana Univ. Press.

Holmes, Oliver Wendell. 1980. "The Stereoscope and the Stereograph." In *Classic Essays on Photography*, edited by Alan Trachtenberg, 71–82. New Haven, Conn.: Leete's Island Books.

*Ilse Bing, Paris 1931–1952.* 1987–88. Ex. cat., Musée Carnavalet, Paris.

Irigaray, Luce. 1977. *The Sex Which Is Not One.* Ithaca: Cornell Univ. Press.

Jaccard, Roland, ed. 1986. *Louise Brooks: Portrait of an Anti-Star.* New York: Zoetrope.

Jameson, Fredric. 1994. *Postmodernism; or, the Cultural Logic of Late Capitalism.* Durham, N.C.: Duke Univ. Press.

*Johannes Vermeer.* 1995–96. Ex. cat., The National Gallery of Art, Washington, D.C.; Royal Cabinet of Paintings Mauritshuis, The Hague.

Katz, D. Mark. 1991. *Witness to an Era: The Life and Photographs of Alexander Gardner.* New York: Viking.

Lackner, Stephan. 1991. *Max Beckmann.* New York: Abrams.

Lawall, David B. 1966. "Asher Brown Durand: His Art and Art Theory in Relation to His Times." Ph.D. diss., Princeton Univ.

Lemoisne, P. A. 1947. *Degas et son oeuvre.* Paris: Paul Brame et C. M. de Hauke.

Lévêque, Jean-Jacques. 1989. *La vie et l'oeuvre de Jacques-Louis David.* Paris: ACR Éditions.

Lo Duca, Joseph-Marie. 1979. *Hippolyte Bayard.* Paris: Prisma, 1943. Reprinted in The Sources of Modern Photography (series), edited by Peter Bunnell and Robert Sobieszek. New York: Arno.

MacCannell, Dean. 1987. "Marilyn Monroe Was Not a Man." *Diacritics* 17, no. 2 (summer).

Meuris, Jacques. 1989. *Magritte.* Paris: Nouvelles Éditions Françaises.

Mitchell, William J. 1992. *The Reconfigured Eye: Visual Truth in the Post-Photographic Era.* Cambridge, Mass.: MIT Press.

Moffitt, John F. 1988. *Occultism in Avant-Garde Art: The Case of Joseph Beuys.* Ann Arbor: UMI Research Press.

Moore, George. 1923. *Modern Painting.* Vol. 19 of *The Collected Works of George Moore.* New York: Boni and Liveright.

Moser, Lynn. 2001. Telephone interview by Ann M. Ryan. September.

Musper, H. T. 1981. *Netherlandish Painting from van Eyck to Bosch.* Translated by Robert Allen. New York: Harry N. Abrams.

Nijinsky, Romola. 1934. *Nijinsky.* New York: Simon and Schuster.

Ottinger-Zingue, Gisèle, and Frederik Leen, eds. 1998. *Magritte: 1898–1967.* Translated by Tiffany Bernard Davidson, Ted Alkins, and Margaret Clarke. Ex. cat., Royal Museum of Fine Arts of Belgium, Brussels.

Ozick, Cynthia. 1997. "A Critic At Large: Who Owns Anne Frank?" *New Yorker,* October 6, 77–87.

Paulson, Ronald. 1975. *The Art of Hogarth.* London: Phaidon.

Perkins, David, ed. 1995. *English Romantic Writers.* Orlando, Fla.: Harcourt Brace College Pubs.

Rewald, John. 1946. *Georges Seurat.* Translated by Lionel Abel. New York: Wittenborn and Co.

Rich, Adrienne. 1973. "I Dream I'm the Death of Orpheus." In *The Norton Anthology of Modern Poetry,* edited by Richard Ellman and Robert O'Clair, 1220–32. New York: W. W. Norton and Co.

Roth, Nancy Ann. 1991. "Electrical Expressions: The Photographs of Duchenne de Boulogne." In *Multiple Views: Logan Grant Essays on Photography, 1983–89,* edited by Daniel P. Younger, 105–37. Albuquerque: Univ. of New Mexico Press.

Sapir, Michael. 1994. "The Impossible Photograph: Hippolyte Bayard's 'Self-Portrait as a Drowned Man.'" *Modern Fiction Studies* (Autobiography, Photography, Narrative) 40, no. 3 (fall): 619–29.

Selz, Jean. 1974. *Edvard Munch.* Translated by Eileen Hennessy. New York: Crown.

Shakespeare, William. 1997. *As You Like It.* In *The Norton Shakespeare,* edited by Greenblatt, Stephen, et. al, 1591–1657. New York: W. W. Norton and Co.

———. 1997. *The Tempest.* In *The Norton Shakespeare,* edited by Greenblatt, Stephen, et. al, 3047–3107. New York: W. W. Norton and Co.

Steinberg, Leo. 1972. *Other Criteria: Confrontations with Twentieth-Century Art.* London: Oxford Univ. Press.

Thoreau, Henry David. 1982. "Walking." In *The Portable Thoreau,* edited by Carl Bode, 592–630. New York: Viking.

Toulouse-Lautrec, Henri de. 1973. *The Complete Paintings of Toulouse-Lautrec.* New York: Harry N. Abrams.

Trachtenberg, Alan, ed. 1980. *Classic Essays on Photography.* New Haven, Conn.: Leete's Island Books.

Tucker, Herbert. 1991. Lecture on William Wordsworth in a course on the History of British Literature at the Univ. of Virginia.

Tynan, Kenneth. 1979. "Profile: The Girl in the Black Helmet." *New Yorker,* June 11, 45–78.

Verdi, Richard. 1992. *Cézanne.* London: Thames and Hudson.

Waale, Kim. 1997. *A Good Look: The Adolescent Bedroom Project.* Sculptural installation at the Munson Williams Proctor Institute, Utica, N.Y.

Warhol, Andy. 1992. *Andy Warhol Polaroids, 1971–1986.* New York: Pace MacGill Gallery.

Warnke, Carsten-Peter. 1995. *Pablo Picasso: 1881–1973.* Edited by Ingo F. Walther, translated by Michael Hulse. Cologne: Benedikt Taschen.

Wharton, Edith. 1995. *The House of Mirth.* New York: Scribner.

Wheelock. Arthur K., Jr. 1981. *Jan Vermeer.* New York: Abrams.

Whitman, Walt. 1982. "Leaves of Grass." In *Whitman: Poetry and Prose,* edited by Justin Kaplan, 27–88. New York: Library of America.

Woolf, Virginia. 1957. *A Room of One's Own.* New York: Harcourt Brace Jovanovich.

# Contributors

RAY BEALE has a master of arts degree in photojournalism from the Newhouse School at Syracuse University. He has taught studio photography at the university's Department of Art Media Studies and in the Communications Department at Ithaca College. He lives in Fabius, New York, and Rome, Italy.

DEBORAH BRIGHT is a photographer and writer on photography and cultural issues. She edited *The Passionate Camera: Photography and Bodies of Desire* (1998), which was nominated for a Lambda Award in visual arts. The recipient of numerous grants and awards for her work, she is a professor of photography and art history at the Rhode Island School of Design.

MICHAEL DAVIS is an associate professor of English at Le Moyne College in Syracuse, New York. He has studied art history at Yale and the University of Paris and wrote his doctoral dissertation on Walter Pater, Sigmund Freud, and the visualization of theory at the University of Virginia. He is currently completing a book project on Virginia Woolf.

JULIE GROSSMAN is an associate professor of English at Le Moyne College, where she teaches film, Victorian literature, and women's studies. She has published essays on Victorian fiction, the representation of photography in nineteenth-century literature and culture, and American film and performance art.

JEFFREY HOONE is a photographer who, since 1980, has been involved in the administration of programs at Light Work, an artist-run nonprofit photography center in Syracuse, New York. As a photographer, he has exhibited his work most recently at P.P.O.W. Gallery in New York City and at the University of Rochester. His work was also included in the Everson Biennial at the Everson Museum of Art in Syracuse.

DAVID LLOYD is a poet and fiction writer who directs the Creative Writing Program at Le Moyne College. He is the editor of *The Urgency of Identity: Contemporary English-Language Poetry from Wales* (1994) and *Writing on the Edge: Interviews with Writers and Editors of Wales* (1997). His poetry collection *The Everyday Apocalypse* won the 2002 Maryland State Poetry and Literary Society's Chapbook Contest. He received the Poetry Society of America's Robert H. Winner Memorial Award in 2002.

PHILLIP NOVAK is an assistant professor of English at Le Moyne College. He has published essays on mourning as a structural and thematic feature of the works of William Faulkner and Toni Morrison.

CHARLES PALERMO is an assistant professor at the College of Staten Island/CUNY. He recently published "Tactile Translucence: Miró, Leiris, Einstein," an essay on Joan Miró's paintings of the 1920s.

CHRISTIAN A. PETERSON is associate curator of photographs at the Minneapolis Institute of Arts. Over the last twenty years, he has organized numerous exhibitions and written many catalogs, primarily on American pictorial photography.

ANN M. RYAN is an associate professor of English at Le Moyne College, where she teaches nineteenth-century American literature, particularly the works of Mark Twain. She has published essays on contemporary responses to Twain, race identity in popular culture, American humor, and the works of the American transcendentalists.

KIM WAALE is an artist and professor of art and design at Cazenovia College. Her sculptures and installations have been exhibited widely, and she has been awarded grants and/or residencies from such organizations as Light Work, the Saltonstall Foundation, the International Studio Program, Sculpture Space, and the Millay Colony.